Photography and Literature

exposures

EXPOSURES is a series of books on photography designed to explore the rich history of the medium from thematic perspectives. Each title presents a striking collection of approximately 80 images and an engaging, accessible text that offers intriguing insights into a specific theme or subject.

Series editors: Mark Haworth-Booth and Peter Hamilton

Also published

Photography and Literature

François Brunet

reaktion books

To Marc, David, Marion and Alex

Published by Reaktion Books Ltd
33 Great Sutton Street
London EC1V 0DX
www.reaktionbooks.co.uk

First published 2009, reprinted 2013

Copyright © François Brunet 2009

The author gratefully acknowledges the support of a grant from Université Paris Diderot – Paris 7 (Laboratoire de Recherches sur les Cultures Anglophones).

Printed and bound in China

British Library Cataloguing in Publication Data
Brunet, François
 Photography and literature. – (Exposures)
 1. Literature and photography
 2. Photography in literature
 3. Literature, Modern – History and criticism
 4. Photography – History
 I. Title
 809.9'3356

ISBN: 978 1 86189 429 8

Contents

DOGOS DU MAVRON 1879

Introduction

In the first decades of its existence, photography was dubbed 'sun painting', a phrase often intended to be derisive, and one which epitomized the seemingly inescapable confrontation of photography's mechanical character to the painter's artistic freedom. This confrontation remained a leitmotiv of virtually all discourse on the invention until, in the twentieth century, photography gained acceptance in the museum and the art market on the basis of a partial assimilation to the model of painting. More recently, an alternative gloss of photography as 'light writing' has gained acceptance to foreground an affinity of photography with literature, or the realm of the written.[1] To many commentators of both the early and the later history of the medium, this sympathy now appears quite as relevant, if not more, as the somewhat forced marriage of photography to painting. From William Henry Fox Talbot's groundbreaking exploration of photography in his extraordinarily subtle book *The Pencil of Nature* (1844–6) to Cindy Sherman's or Sophie Calle's impersonations in fictional photographs, and not least to the countless insights offered by writers engaging photography either as a theme or a companion, the relationship of photography to literature now forms a vital part of the medium's complex history, and has become an ever growing field of inquiry.

Yet the order of the terms in the title *Photography and Literature* may seem somewhat provocative. Most accounts of photography's relationship to literature published so far have been told by literary scholars, from the point of view of literature, and are therefore more often identified as studies of 'literature and photography'.[2] Anthologies and surveys have

1 Louis Ducos du Hauron, *Landscape at Agen*, 1878. Heliochromy obtained by author's trichrome process.

concentrated on the ways in which writers received photography, rejected or incorporated it in their work, and in some cases collaborated with photographers; broader investigations have considered the growing incorporation of images into modern literature.[3] More theoretically minded critics have addressed the issues of the writing or the framing of photography by literature, as well as of the reordering or de-ordering of literature by the experience of photography. Yet a recurring assumption is that literature is the older, the broader, the more regulated and the more established cultural form, while photography is (still!) the newcomer, the alien, if not the troublemaker. Roland Barthes, arguably photography's most influential critic, described in his *Camera Lucida* (1980) the 'trouble' introduced by the advent of photography. His own intellectual background, as literary scholar turned semiotician and then philosopher of the photograph, testifies to a cultural matrix for which photography remained something of a novelty, and an intruder of sorts in the older and more serene realm of literature. To be sure, much the same pattern may be observed in traditional western narratives of the relationship between word and image, or written and visual cultures, and such narratives have deep roots in western philosophy.[4] Without claiming to address such a broad intellectual genealogy, this book departs from the mainstream of studies on literature and photography in two complementary ways.

On the one hand, as the title makes explicit, I attempt to reverse the angle of vision by looking at photography's encounters with literature from the point of view of photography and photographers. Such a choice (which need not be exclusive of the more habitual literary angle) is obviously no small order, for the 'point of view of photography' is not easily located or unified. While we have a growing corpus of literary 'interactions' with photography, to use Jane Rabb's excellent term,[5] the history of photographic involvements with literature remains a shadowy and fragmented subject. During most of the nineteenth century and indeed into the twentieth, photographers were in general not writers, or did not write publicly, and, assuming that 'photography' can be isolated as a homogeneous cultural entity, it did not aspire to the status of literature. This estrangement of photography from literature (which admitted important early exceptions) only changed – in part – in the

wake of Modernism and the growing recognition of photography as a distinct art form. In the second half of the twentieth century this shift grew more solid and diverse at the same time, the photo-book becoming perhaps the 'serious' photographer's most adequate and desirable mode of expression, and in many prominent examples involving a 'serious' writer's stance. At the same time, increasing numbers of writers turned to photography either as a major topic for fiction or as a parallel artistic practice. Still, obviously, not all uses and users of photography espoused literature as a companion, and to this day the common practices of photography, as well as its popular cultural uses, have perpetuated diverse and sometimes indifferent relationships to literature. Thus the *emergence* of a photographic point of view on, or in, literature would be a more modest way of phrasing this shift, both in the sense of photography's self-consciousness emerging in history and in the sense of this point of view manifesting itself in eclipses, peculiar moments, epiphanies. In this respect, the present book can be understood as a history of an emergent meeting between photography and literature.

Literature, conversely, is not so solid or clear-cut a domain as the foregoing remarks might make it sound. No less important to the design of this book is a second premise, calling for a broad and dynamic definition of 'literature'. In English, as well as in French and German, the word *literature* changed meaning in the first half of the nineteenth century. Until then, it had been a very inclusive term, covering virtually every aspect of written or printed culture; science, insofar as it was written, was routinely defined as a 'literary pursuit'. This older definition needs to be borne in mind when envisioning the beginnings of photography, which were deeply enmeshed in written and printed culture. More generally, the larger sense of literature as text or commentary is relevant to my purposes, insofar as photography has so often been presented as an alternative to it. Meanwhile, the birth of photography more or less coincided with the advent of a more strictly delimited and increasingly prestigious realm of 'literature'. In France the publication in 1800 of Madame de Staël's *De la littérature* was an important step. In the wake of German Romanticism, literature (like art) was now envisioned as both cultural heritage, especially national, and individual pursuit with a reflexive, aesthetic ambition, as well as a claim to deliver truths about society.[6] After 1830 or so, in West European and North American dictionaries, the word for 'literature' started to become specialized as a label for the collective production of writers and for 'literary' practices, especially fiction and poetry. This redefinition of literature – consistent with M. H. Abrams's larger thesis of the transformation of the role of art from 'mirror' to 'lamp'[7] – was by no means purely semantic and instead resulted in the establishment of literature as the major cultural expression of both the Enlightenment and Romanticism, arguably the quintessential or most authoritative expression of (western) culture.[8]

My intention, then, is to draw attention to the coincidence of the invention of photography and the idea of photography as a technically and socially based standard of (visual) truth, with this post-Romantic advent of literature as the culturally sanctioned expression of the creative self. This coincidence has not been emphasized as much as other comparable parallels – such as photography and positivism, photography and history – precisely because these two inventions of the early nineteenth century seemed so antagonistic. Photography was durably associated

with 'realism' and its various brands, whether philosophical, economic or aesthetic, and thus it seemed to run counter to a literary enterprise that defined itself, at least partly, as the expansion of an individual imagination particularly drawn to invisible truths. If Romanticism can be defined, among other things, as the striving of the artist to establish the self as 'seer' and 'sayer', then in some ways photography, or the idea of photography, can be considered largely anti-Romantic – a force of assertion of the 'one', the 'we', the discourse of nature and society, poised against individual expression. Such a picture is obviously very coarse, even fragmentary, be it only because one of photography's inventors, Talbot, demonstrated in his *Pencil of Nature* that photography could indeed serve individual expression and Romantic aesthetics. For this reason Talbot is a major topic in this book. *The Pencil of Nature* was, however, a unique endeavour in its time, and, as we shall see, a far cry from a global *rapprochement* of photography and literature. Yet from an early twenty-first-century standpoint, many signs suggest that photography, or at least some prominent branches of it, have indeed managed to espouse literature, while much literature has increasingly turned to photography for the renewal of its sources and forms – to the point of producing a hybrid, a 'photo-literature' or 'photo-textuality'[9] concerned primarily with the exploration of its own structures and practices. Thus, while this book engages a broad history of relations between photography and literature, one of the questions it raises is how photography has come to adopt the Romantic cult of the self, to the point of becoming its standard expression. Conversely, it will also suggest that various deconstructionist trends of the twentieth century, culminating in Postmodernism, have sought out photography or the image as a tool to aid the emancipation of literature from these Romantic origins.

I hasten to add, however, that this short book does not claim to prove, or even to construct, a grand historical system – but more modestly to delineate some patterns of evolution, relying on the solid groundwork laid out by previous historians (Alan Trachtenberg, Jane Rabb, Jan Baetens, Nancy Armstrong, Philippe Ortel, Bernd Stiegler, among others). Although the general approach is chronological, the division of chapters identifies five themes or viewpoints – inevitably ignoring or downplaying others,

and allowing also some overlap. In chapter One, 'Writing the Invention of Photography', I concentrate on photography's beginnings and how the invention and its publication were shaped by written culture – including science and literature. In chapter Two, 'Photography and the Book', this foundational connection is followed up in the later alliance of photography with the space and economy of the book, which I describe as the medium's premier mode of circulation. In chapter Three, 'Literary Discoveries of Photography', I survey the immense record of writers' responses to photography, treating Roland Barthes' *Camera Lucida* as the recapitulation of the ongoing discovery of photography that usually signalled its foreignness to the project of literature. In chapter Four, 'The Literature of Photography', I revert to 'photography's point of view' to sketch a history of literary experiments by photographers, whether as autobiography, manifesto, fiction, or, more recently, acting. Finally in chapter Five, 'The Photography of Literature', I seek to complete the depiction of a process of hybridization by outlining the various modes in which photography has been called upon to image literature, from portraits of writers to illustrated texts and, again recently, 'photo-textual' experiments. As we shall see, discernible conceptual patterns do emerge in this history, concerning especially photography's relationship to reality, presence, and representation – particularly of the self. Still, this history is envisioned primarily as cultural, linking ideas and practices in an investigation of art in society.

Writing the Invention of Photography

The word is properly spelt Daguerréotype, and pronounced as if written Dagairraioteep. The inventor's name is Daguerre, but the French usage requires an accent on the second e, in the formation of the compound term.

Edgar Allan Poe, 1840[1]

Although a now age-old critique of modernity has associated photography with the birth of 'the image' or the 'mediasphere'[2] and a parallel demise or decline of written culture, photography's beginnings hardly resemble a flood of images upsetting the ancient pillars of writing. The creation of the word *photography* itself reflected the print tradition (John F. W. Herschel linked the word to *lithography* and *chalcography*) rather than the popular glosses as 'sun painting' or 'light image', while Talbot's earlier suggestion of *skiagraphy* ('drawing [or] writing with shadow') related his invention to writing.[3] Many of the pioneers' first experiments involved the copying of written or printed documents, including lithographs in Niépce's case, diplomas in Hercules Florence's, and manuscripts in Talbot's early photogenic drawings. For the historian, the investigation of photography's dawn is largely a matter of exploring written sources – often with tangled histories of their own – rather than relying on 'the images themselves', if indeed images ever present themselves free from printed and written contexts in the nineteenth century. In any account of the invention of photography, scientific or legal discourse and genealogical narratives tend to overwhelm the photographic content, which is scarce and sometimes visually mediocre. Those

genealogical narratives, acknowledging both the revolutionary character of photography's invention and its roots in a seemingly universal 'dream of mankind', often resort to literary sources and devices to substantiate the newer medium. Finally, the amount of written discourse that accompanies early photographic images testifies to the ancillary status of photography in its first years and even decades.[4] While nineteenth-century photographers generally did not write much, many served the literary or scientific agendas of others with more or better opportunities for writing, and performed social functions whose significance was only recorded – if it was – by writers and journalists. Thus I will argue in this first chapter that the invention of photography must be envisioned squarely in its *written* condition – a condition that, in some respects, the later development of the medium would tend to break away from.

Most scholars agree that the sequence of events in 1839 that led to the publication of the first photographic processes marks the beginning of the (public) history of photography. This sequence started with the inaugural session of the French Academy of Sciences on 7 January, where physicist François Arago gave the first, partial description of Daguerre's 'results', and continued with Talbot's subsequent communications to the English learned bodies. The advent of photography took the form of a Franco-English academic rivalry, attended by a phenomenal amount of sensation in the press of the industrialized world, and concluded in France by the granting of a state pension to Isidore Niépce and Daguerre in exchange for the publication of their processes.[5] As a whole, this sequence was permeated by discourse and writing; it happened by way of telling, rather than showing. Between the end of 1838 and the fall of 1839, when more practical details emerged, very few persons outside the inventors' circles, members of learned bodies and European governments had access to the various kinds of pictures produced, let alone the processes involved. Even

3 Nicéphore Niépce, *Le Cardinal d'Amboise*, February 1827. Heliograph reproduction of a 1650 engraving. Proof on paper printed by engraver Lemaître from the original plate obtained by Nicéphore Niépce in 1826.

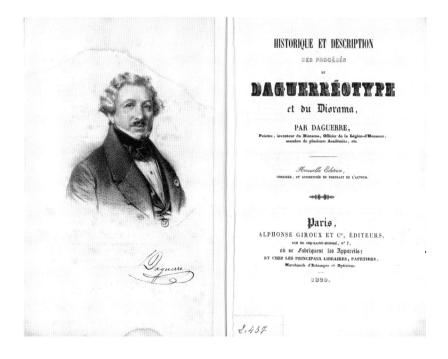

4 Frontispiece, with engraved portrait of Daguerre, and title page from Louis-J.-M. Daguerre, *Historique et description des procédés du daguerréotype et du Diorama* (Paris, 1839).

though Daguerre repeatedly warned that 'the most detailed description cannot suffice, one needs to watch the operation',[6] the French official procedure included no opportunity to do so (except for Arago himself) – and even Daguerre's plates were hardly exhibited until June, when the pension bill was introduced in Parliament. It was not until August of 1839 that a joint session of the academies of sciences and the fine arts finally divulged Daguerre's process – and again it was Arago who spoke, Daguerre having declined to speak on account of 'a sore throat' and 'some shyness'.[7] Even then, few people saw his small plates, and the bizarre word *daguerréotype* signalled first and foremost a mystery.

Talbot was more forthcoming with his photogenic drawings, displaying a number of them at the Royal Institution as early as 25 January of 1839, though he did not forward them to Paris for comparison or to support the claim of priority he filed with the French Academy of Sciences. Indeed, what Larry Schaaf has called his 'dilemmas' revolved around when and how to publish his 31 January memoir to the Royal Society.[8] Several other

inventors' claims were similarly supported by written descriptions. To be sure, the written condition of the invention of photography was a function of the fragile and elusive nature of the visual evidence available to those in charge of appraising the invention. Guarded behaviour was also motivated by the inventors' protectiveness of their secrets and Daguerre's urge to capitalize financially on the process. Nevertheless, these factors ultimately reflected the logic of evaluation itself, which, because its stakes were legal, essentially rested on (legal) language. Insofar as both daguerreotype and photogenic drawing, as well as lesser competitors, claimed recognition as *inventions*, rather than art forms, and the more so because in France a national reward was at stake, the early stages of photography were manifested in a series of legal proceedings to which the emergent Franco-British rivalry (as well as Arago's left-leaning politics) added nationalistic and ideological dimensions. Language, then, both as writing and as oratory, was photography's primary channel of communication. (Had the scientific bodies wished to somehow publish their findings *visually*, the best they could have done would have been to transcribe photographs as engravings. Photography, including Talbot's photogenic drawings in their early form, could hardly represent itself publicly. Only with *The Pencil of Nature* would Talbot achieve a first, successful self-representation of photography.) And for the world at large, indeed even for many scientists, seeing a photographic image came long after reading about it in the press or on bills and placards, as shown in Théodore Maurisset's famous cartoon on 'daguerreotypomania'. Photography – like all nineteenth-century inventions – was experienced as an event, and in writing, before it was encountered visually. This pre-emption of fact by discourse meant photography would be received as an idea or text rather than as a picture, let alone as an experiment. For an invention described as 'Nature representing herself' this situation was quite paradoxical: the natural image, before ever meeting the public's eye, was inscribed as the child of culture.

Equally as striking is the fact that this process of affiliation, while registering the invention of photography squarely in the realm of science, often communicated its novelty in the language of literature. As Paul-Louis Roubert notes, Arago's partial disclosures lent the daguerreotype the aura

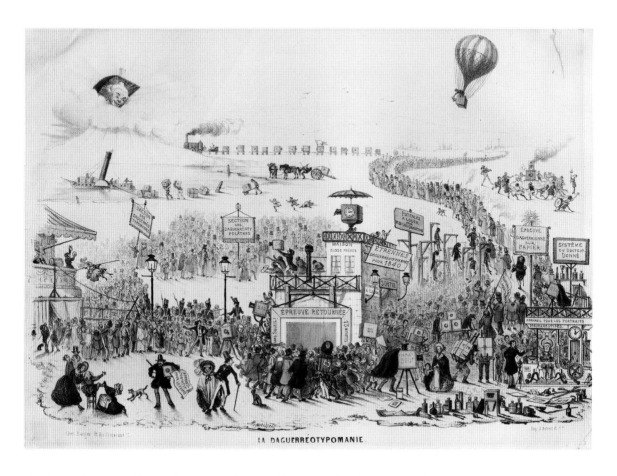

LA DAGUERRÉOTYPOMANIE

5 Théodore Maurisset, *La Daguerréotypo-manie*, December 1839, lithograph with applied colour.

of a cultural creation, if not a legend, rather than a scientific discovery; this is particularly evident in the account given by the critic Jules Janin in *L'Artiste* of 27 January 1839, often considered the most influential early press account, which extolled the daguerreotype as a modern realization of the biblical *Fiat lux* and particularly marvelled at its ability to record the most minute detail – down to 'grains of sand' – as well as, even more improbably, 'the shadow of a passing bird'.[9] Still more revealing are the various letters written by privileged viewers of Daguerre's plates to correspondents in different parts of the world. Whether intended for publication or not, they display remarkable efforts to mediate the experience, and in so doing tend to oscillate between the language of

science and that of poetry, or fiction, and fantasy. Alexander von Humboldt, who, as emeritus of the Academy of Sciences and personal friend of Arago, was one of the select few in the evaluation committee, wrote such a letter to Carl Gustav Carus on 2 February 1839. Though remarkably sober in its general tone, this letter records the quasi-magical revelation of vivid detail by the daguerreotype. A magnifying glass applied to a view of the Louvre court reveals 'blades of straw at every window', while Humboldt later marvels that in the fixing of the plate 'the blade of straw is not erased!'[10] As Roland Recht has shown, the fascination for detail registered by such exclamations, along with the sensuous appeal and the inner resonances of a seemingly natural process of landscape-making, echoes recurring concerns of Romantic literature and aesthetics. This is illustrated, for instance, in tales by E.T.A. Hoffmann or Nathaniel Hawthorne – even though much of Romantic aesthetics emphasized the primacy of a 'subjective' observer that, as Jonathan Crary has suggested, may be construed as anti-photographic.[11]

Less subtle than Humboldt's, but much more explicitly fantastic, is the letter written by Samuel F. B. Morse to his brothers on 9 March 1839. The American painter–inventor had visited Daguerre's studio during a stay in Paris, where he hoped to marshal support for his electromagnetic telegraph. Published verbatim in the New York *Observer* of 20 April, this letter functioned as a public announcement of the invention in the United States.[12] Like other commentators, Morse not only used the most incongruous superlatives about Daguerre's plates ('they are Rembrandt perfected') but also situated them in the realm of the marvellous or, indeed, of the fantastic. In his evocation of Daguerre's view of the Boulevard du Temple, Morse delivered a minute description of the scene *as it appeared in the picture:*

> the Boulevard, so constantly filled with a moving throng of pedestrians and carriages, was perfectly solitary, except an individual who was having his boots brushed. His feet were compelled, of course, to be stationary for some time, one being on the box of the boot-black, and the other on the ground. Consequently, his boots and legs are well defined, but he is without body or head because these were in motion.

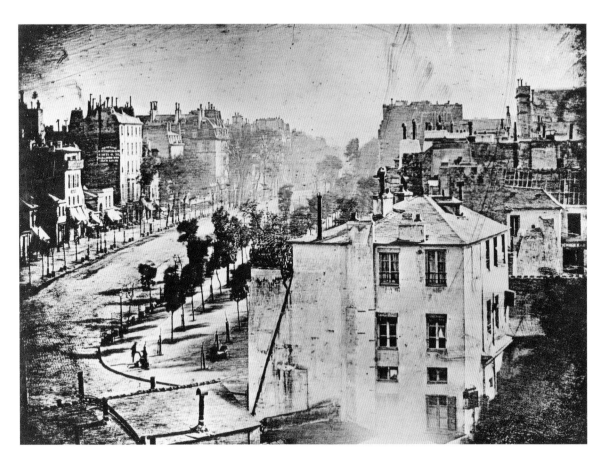

6 Louis-J.-M. Daguerre, 'View of the Boulevard du Temple', 1838/9, daguerreotype. Another image in the same series, now lost, showed the man having his shoes shined at lower left 'without body or head'.

This ekphrasis reads as a fantastic tale a la Poe, and for that reason, according to Robert Taft, many treated it as a hoax. It inaugurated, incidentally, photography's connection to absence and (symbolic) death, while squarely inscribing it in public consciousness as fantasy. Such fantastic readings were not isolated, nor reserved to provincial or popular commentators; they filtered through the most official statements of 1839.

One spectacular, if little known document testifying to an early 'literary invention' of photography is the epic poem 'Lampélie et Daguerre' penned by Népomucène Lemercier, a prominent French academician, semi-official writer and composer of neo-classical tragedies and allegorical poetry, who specialized particularly in a kind of modern mythology.

Asserting in his preface the duty of modern writers to celebrate the achievements of their times in the eternal language of mythology, Lemercier wrote the history of Daguerre's invention as an episode in the ongoing quarrel between two daughters of Apollo, Lampélie, goddess of light, and her sister Pyrophyse, goddess of fire. The long versified epic treated the destruction by fire of Daguerre's Diorama on 6 March 1839 as an act of vengeance on the part of the jealous Pyrophyse. It concluded with the successful wedding, sanctioned by Apollo's decree, of Daguerre and the glowing Lampélie, bearing fruit in the daguerreotype and opening the way, under Arago's guidance, for the photographic exploration of 'the empire'.[13] This contrived piece, which was read to the annual joint session of the five French academies on 2 May 1839, has rightly been put aside in anthologies of literature and photography. Yet Lemercier's ode inaugurated a mythological – arguably even theological – reading of photography as a Promethean feat that would become a routine feature of nineteenth-century essays on the subject.[14] Though a mere accessory in the vast patriotic campaign that effected the glorification of Daguerre in France, it fully illustrated the academic culture that, in France at least, shaped the reception of photography. In this academic context, the invention of photography was publicized as a new paradigm, not only questioning the accepted relationships of science to art, but foregrounding invention itself as a marvellous phenomenon. Because this invention escaped the reach of full scientific explanation, but more importantly because it was presented as beneficial to society as a whole, it seemed to compel its champions to describe it in 'literary' terms.

This is particularly evident in the famous speech given by François Arago to the Chamber of Deputies in June 1839, as support for the pension bill. Walter Benjamin wrote of this speech, which was widely reproduced and quoted for years, that 'it pointed out photography's

LAMPÉLIE ET DAGUERRE,

POËME.

O fille d'Hélion! brillante Lampélie,
Déité colorant la nature embellie,
Corps subtil qu'on ne peut ni saisir, ni peser,
Qu'en sept anneaux distincts Newton sut iriser,
Sans révéler au prisme, où notre art te déploie,
Si ta clarté rayonne ou dans l'éther ondoie,
Lumière!.... que mon œil ne voit plus qu'à demi.....
Du triste sort d'Homère, ah! j'ai déjà frémi.
M'as-tu voulu punir d'imiter le poëte
Qui de l'Olympe ouvert se créa l'interprète?
Second Tirésias, ai-je donc mérité
De traîner au tombeau sa noire cécité?
T'offensai-je autrefois, déesse au front lucide,
De signaler ta course, en chantant l'Atlantide,
Quand ma muse puisa dans ton berceau vermeil
Ta splendeur paternelle, essence du soleil;
Quand j'osai te donner sur le luth d'Uranie

4

7 The opening lines of an allegorical poem, 'Lampélie et Daguerre', by Népomucène Lemercier, *Sur la découverte de l'ingénieux peintre du Diorama . . .* honouring Daguerre, read at the French Academy on 2 May 1839 (Paris, 1839).

applications to all aspects of human activity'.[15] It is worth noting that this universality of photography was partly predicated on the abstraction of a technical invention and a manual practice – of which Arago hardly said anything – into a formidably simple and appealing *idea*. This abstraction was expressed most concisely by the Minister of the Interior, Tannegni Duchâtel, when he declared to the French deputies that Daguerre's invention could not be patented because it was really more of an idea than an invention and that, once it was published, 'everyone [would] be able to use it.'[16] I have elsewhere commented at length on this idea, which brings together the notions of the natural (or an art without art) and the democratic (an art for all) – or, as Roland Recht suggests paraphrasing Paul Valéry, 'the least possible Man' (in its creation) and 'as many men as possible' (in its subsequent usage).[17] For Arago's progressive and even radical-leaning politics, photography represented a precious asset. The idea of photography could serve a Saint-Simonian programme of state-supervised modernization, but, in a more strictly political vein, it supported the advancement of democratic ideals – be it only in the cultural realm – for which the notion of a self-generated representation could be an appealing metaphor. One of the most telling aspects of Arago's speech to the French Parliament was that, far from dwelling on the scientific origins, interpretations, or uses of photography, it adopted a non-specialized stance – a layman's discourse, which posited photography as universally accessible, an addition to culture rather than science. The Secretary of the Academy of Sciences went so far as to stress that Daguerre's process was not yet fully explained scientifically, and that he would postpone this task until after the passage of the bill. Thus, as the representative of science's authority to reward the inventors and, in the famous phrase, to 'give photography to the world', he was simultaneously stressing the estrangement, indeed the alienation, of invention, inventors, technology, and practice from the ideal logic of science. Bewilderment at the magic of the daguerreotype, combined with the urge to make the idea of photography as generic and accessible as possible, explain Arago's recourse to literary references and devices in a speech celebrating photography's modernity.

This was a speech intended to support the project of a state grant for two inventors, and Arago had to prove that their results were indeed new and original. Hence the need for a *history* of the invention, which from then on became an important source of a literature of photography. Arago's narrative of the genesis of photography was superlatively Rationalist, and yet it left room for bewilderment. On the one hand, photography was the positive brainchild of modern science, or of modern invention explicated by science, and as such it terminated centuries of fruitless speculation. On the other, its realization at the hands of Niépce and Daguerre was the serendipitous fulfilment of an 'old dream of mankind', and as such displayed the logic of desire rather than that of reason,[18] and a marvellous character that numbed science and its verifiable procedures. On one side, photography was the end of 'literature', in the sense of vain textual speculation; on the other, 'literature', in the sense of record of the imagination, was the image of photography.

Thus Arago first took pains to distinguish between the positive invention, a verifiable and repeatable fact, and the 'old dream of mankind' that had nourished and preceded it.[19] Bemused Parliament members were told that 'the dream has just been realized', which implied that the invention had been a dream, but was no longer. This photographic aurora from centuries of darkness was heightened by the sketch of a whole prehistory of photography, the first elaboration of what would become a substantial sub-genre of photo-history. Arago's genealogy typically reached far and wide, and typically zeroed in on debatable sources. He initiated, first of all, the alchemical lineage of photography, erroneously attributing the invention of the *camera obscura* to Giambattista della Porta, the sixteenth-century Italian polymath. Coming from one of the day's foremost specialists in optics, such an attribution, which ignored the whole scholarly optical tradition from Aristotle to Newton, was clearly biased. Equally revealing, considering that in 1839 the scientific community at large saw the invention as a breakthrough in chemistry, rather than in optics, was Arago's cursory treatment of the chemical prehistory of Daguerre's use of iodized silver (especially in English- and German-language eighteenth-century

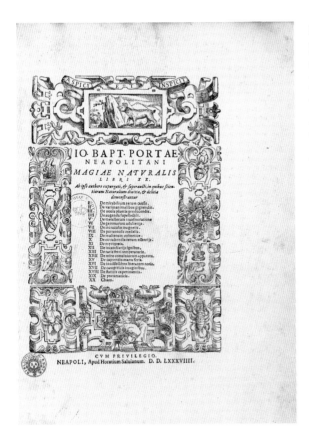

8 Title page of Giambattista Della Porta, *Magiae Naturalis Libri xx* (Naples, 1589).

photochemistry). That the Porta connection was popular in 1839 is demonstrated by the existence of a seventeenth-century portrait of Porta among Daguerre's papers.[20] Photography's relationship to alchemy has been explored by historians since Arago,[21] but Arago clearly had a different agenda. The French physicist was looking for a spectacular, i.e. an anti-rational, ancestor of photography, as becomes apparent in another passage of his genealogy. Eager to contrast the French inventors' achievement with pre-Enlightenment darkness, Arago alluded *a contrario* to 'the extravagant conceptions of a Cyrano [de Bergerac] or a [John] Wilkins'.[22] Cyrano de Bergerac was the famed author of *Voyage dans la Lune* (1657), and a popular reprint of his tales had been in circulation since 1787 (Daguerre's birth year). John Wilkins, bishop of Chester, first secretary of the Royal Society, published in 1638 and 1640 two books about the discovery of 'a world in the moon', and in 1641 a treatise on cryptography which remained popular in the seventeenth and eighteenth centuries. Both these references are significant, not only because they linked the invention of photography to a classic epitome of scientific fantasy – travel to the moon (Humboldt marvelled in his letter to Carus about Daguerre's 'portraits' of the moon), but also because they were fairly unspecific. Neither Cyrano nor Wilkins had anything to do with the prehistory of photography; they came into Arago's argument as popular instances of the 'extravagant' that served to highlight the decisive separation of photography's reality from its literary limbo.

Later commentators, from the mid-1840s on, would augment the genre of 'literary premonitions of photography', particularly with the rediscovery of an obscure French eighteenth-century novel of imaginary travel, *Giphantie*, which featured 'elementary spirits' fixing mirror images with a special coating and which became an important source for

champions of the prophetic powers of literature.[23] It became customary to relate photography and other inventions of the century to the classics of fantasy, for instance *The Arabian Nights*.[24] Around 1900, the Austrian chemist Josef-Maria Eder carried out encyclopaedic researches on the history and especially prehistory of photography, which led him to gather a dizzying collection of literary premonitions including, for instance, some rather obscure lines by the Latin poet Statius. In the twentieth century, Helmut Gernsheim, basing himself on Eder and other German-language historians, would popularize a very broad narrative of 'the origins of

9 E.J.-N. de Ghendt's engraved illustration of a traveller galloping on an ostrich, from Cyrano de Bergerac's 'L'histoire des oiseaux' in *Voyages imaginaires, songes, visions et romans cabalistiques*, XIII (Amsterdam, 1787). This collection of imaginary travel narratives also contained Cyrano's *Voyage to the Moon*.

10 W. Marshall, engraved frontispiece of *A Discourse Concerning a New World & Another Planet in Two Books* (London, 1640), the first book being John Wilkins's *The Discovery of a New World*.

photography', and conclude that 'the greatest mystery in the history of photography' was that 'it was not invented earlier', thereby diluting much of the explosive character of its appearance in 1839.[25] By the year 2000, the invention of photography – now also related to Asian tales of the 'magic paintbrush' – had become a seemingly universal myth, and a largely overdetermined event.

Arago, on the contrary, sought first and foremost to present photography as a revolution. While the French academician highlighted the superior power of science as midwife to this breakthrough, he did not shrink from enlisting the magic of chance among the new fields disclosed by photography. Further on in his speech, he dwelt on the 'unexpected' as a source of inventive progress, giving the example of 'some children accidentally [placing] two lenses in opposite ends of a tube' and thereby inventing the telescope.[26] In his 1840 commentary on the daguerreotype, Edgar Allan Poe would pick up on this bit of rationalist mystique, insisting in close echo to Arago: 'it is the unforeseen upon which we must calculate most largely.'[27] The secretary of the Academy of Sciences was, in fact, not above adding drama to the whole procedure, which led some of the more conservative scientific circles to fault him for tainting the invention with mystery and sensation instead of explaining it away.[28] Indeed Arago invoked the literature and literary effects of his time as much as he revoked the 'extravagant conceptions' of the past, and his picture of photography appealed to the modern literary imagination in several ways. In his adroit recapitulation of photography's genesis he combined the vast perspectives of world scientific history and the individual merits of the (French) inventors, turning first the spotlight on 'the late Mr. Niépce, a retired landowner in the vicinity of Châlon', who 'devoted his leisure to scientific researches'.[29] In casting this figure of a gentleman farmer turned successful (if erratic) inventor, Arago evinced the somewhat populist and Balzacian image of a solitary, provincial genius privately working out wonders that illustrious scientists had failed to approach. For Arago, in finding a way of 'fixing' his images, 'the ingenuous experimenter from Châlon' had 'solved, as early as 1827, a problem which had resisted the superior sagacity of a Wedgwood or a Humphry Davy'.

To be sure, such a eulogium served a patriotic cause; but at the same time it managed to insert the invention of photography into a more common culture, a layman's modernity, of which biography – both historical and fictional – was one of the privileged languages. Arago was a renowned author of lives of scientists and inventors. As for fictional biography, Balzac especially created several characters of inventors (some rather mysterious) in novels such as *Louis Lambert*. Nadar, in his *Panthéon Nadar*, or Mathew Brady, in his *Gallery of Illustrious Americans*, would forcefully link photography to the illustration and popularization of biography as the modern genre of heroism. Later commentators would expand *ad libitum* on the inventors' biographies and their moments of serendipity, creating, as Louis Figuier and Francis Wey in France, a whole legend around the invention of photography.[30] Finally, in what was perhaps the most vibrant passage of his speech, devoted to the 'extraordinary advantages' to be derived from the daguerreotype for the reproduction of hieroglyphics, Arago chose to refer, in the past conditional and in a clearly nostalgic tone, to one of the founding moments of French Romanticism, the Napoleonic era and especially Napoleon's Egyptian expedition: 'everybody will realize that had we had photography in 1798 we would possess today faithful pictorial records of that which the learned world is forever deprived of by the greed of the Arabs and the vandalism of certain travellers.'[31] Again, this claim displays a patriotic, Arabophobic, and even Anglophobic, stance. Yet from the standpoint of French literary taste, it closely echoed the mood of such landmark Romantic texts as Alfred de Musset's *Confession of a Child of the Century* (1836), the mournful lament of a youth frustrated after 1815 in his anticipation of glorious future, or Stendhal's *Chartreuse de Parme*, published in 1839 – the very year of Arago's speech – which began with a grandiose

11 Francis Wey, 'Comment le soleil est devenu peintre…' ('How the sun became a painter: History of the daguerreotype and photography'), from *Musée des familles*, June 1853. Engraving drawn by Gustave Janet, showing 'Daguerre discovering the effect of a spoon left on a plate'.

and ominous tableau of the battle of Waterloo. Romantic memories also permeated Daguerre's plates.

Memories of Waterloo, Napoleon, and the demise of the Empire, indeed, functioned in 1839 as a symbolic backdrop for the Franco-British rivalry over the invention of photography, and not just in France. In his private research notebooks of July 1839, a Daguerre-obsessed Talbot used the names 'Waterloo' and 'Wellington' to refer to a variety of chemically prepared papers,[32] and later he continued to refer to a class of 'Waterloo papers' which he hoped would establish his revenge over the daguerreotype. As Larry Schaaf aptly writes, 'Talbot's *Waterloo* and *Wellington* papers were barbed reminders of his attitude towards his French rival.'[33] For Talbot, as for Arago, however, Egypt and the Napoleonic wars were not only the theatres of 'nationality', Talbot's word for patriotism. They were also sites of memory, deeply coloured by literary treatments of the post-Revolutionary wars and of Napoleon's figure himself, as the European hero and anti-hero that Romantics from Goethe to Ralph Waldo Emerson did not cease scrutinizing as a herald of modernity. Talbot himself took part in this cult, albeit ambiguously, when, in 1839, he produced a photogenic reproduction of the autograph manuscript of a stanza of Byron's

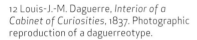

12 Louis-J.-M. Daguerre, *Interior of a Cabinet of Curiosities*, 1837. Photographic reproduction of a daguerreotype.

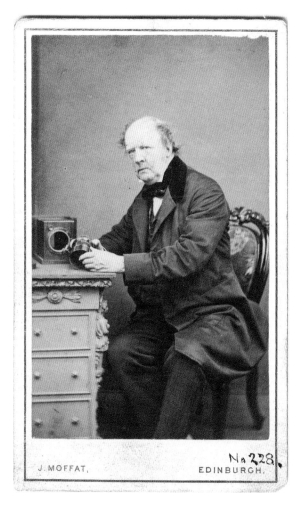

14 John Moffat, *Portrait of W.H.F. Talbot*, 1864; albumen print on a *carte-de-visite*.

13 William Henry Fox Talbot, 'A Stanza from the *Ode to Napoleon* in Lord Byron's Hand'. Photogenic drawing negative of Byron manuscript, before April 1840.

'Ode to Napoleon' as an illustration, intended for Herschel, of his vision of 'every man his own printer and publisher' through the agency of photography.[34]

The English inventor, like his sometime photographic partner John W. Herschel and other Royal Society supporters, was deeply aware that the scientific and diplomatic contest over the invention of photography was also a contest of narratives. Talbot's paper of 31 January 1939, read for him at the Royal Society, was significantly titled 'Some Account of the Art of Photogenic Drawing . . .', where the word *account* announced a discourse that, though very different from Arago's, was genealogical as much as it was descriptive. 'In the spring of 1834 I began to put in practice a method which I had devised some time previously', Talbot's paper began.[35] That *photogenic drawing* was considered by Talbot a process of birthing and becoming or appearing – a genesis or an epiphany – is suggested by the term itself, which Talbot would later drop at the advice of Herschel. Even granting that this process was still being perfected at the time of his paper, one is struck by Talbot's insistence on *narrating* his experiments, not only in the first, more historical, section, but in many passages of the paper, where descriptions of effects and methods are regularly interspersed by autobiographical statements, for example in §3:

> at the very commencement of my experiments upon this subject, when I saw how beautiful were the images which were thus produced by the action of light, I regretted the more that they were destined to have such a brief existence, and I resolved to attempt to find out, if possible, some method of preventing this, or retarding it as much as possible.

Talbot was countering Arago's claims, but not only by declaring the invention of a different, original (and English) process. Using the first person past tense throughout ('I thought', 'I resolved to attempt', 'I discovered'), and noting that before him few if any researchers had apparently 'followed up to any extent' the same idea, Talbot was writing the invention of photography as a personal matter involving both experiment and experience. Whereas Arago would talk of a 'dream of mankind' and outline a broad (if fictitious) prehistory of photography, Talbot emphasized, in this paper, as in many later productions, his invention as a private dream, a solitary adventure, and something of a chance event. Arago, seeking to maximize the rhetorical effects of his intervention, would forge the figure of Niépce as an isolated and somewhat fanciful inventor, as if photography had needed a storyteller to become fully public and intelligible. Talbot, on the contrary, not only made himself the narrator of his own invention but clearly chose not to separate, in his 'account', any statement of 'results' or methods from either the procedures of experiment and deduction that led to them or the wonders and emotions they raised in his mind. In a famous passage titled 'On the art of fixing a shadow', the inventor of photogenic drawing – who had, in 1830, penned a poem called 'The Magic Mirror' – spelled out the very marvellous or magical character of photography that Arago would consistently strive to keep at bay (even as he made use of it for propaganda purposes). Talbot suggested by the same token that the thought and process of 'fixing' a shadow were ultimately more seductive than the result on paper:

> The phenomenon which I have now briefly mentioned appears to me to partake of the character of the *marvellous* . . . The most transitory of things, a shadow, the proverbial emblem of all that is fleeting and momentary, may be fettered by the spells of our *'natural magic,'* and may be fixed for ever in the position which it seemed destined for a single instant to occupy.[36]

Roland Barthes wrote in *Camera Lucida* that the advent of photography divided the history of the world. Thus it is not surprising that, after 1839 and until the present day, the *event* of photography's invention has

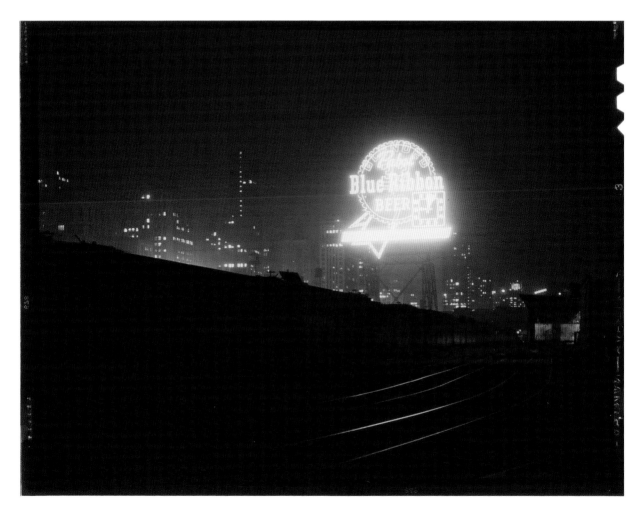

15 Jack Delano, *Illinois Central R.R., freight cars in South Water Street freight terminal, Chicago*, 1943, colour transparency.

continued to inspire historical as well as literary imaginations. I have already mentioned the formidable development of encyclopaedic researches in the prehistory and development of photography. Because the invention of photography has been told so many times, from so many different points of view and within so many frameworks, and because it continues to elicit, in Richard Bolton's phrase, 'a contest of meaning', it has become in itself a paradigm event and something of a literary genre. In 1867 the future Pope Leon XIII composed a poem on

'Ars Photographica', as one of James Joyce's characters recalls in *Dubliners*.[37] In the twentieth century, authors such as Adolfo Bioy Casares and Guy Davenport have tackled the story of the invention and shown, at least in Davenport's highly sophisticated, Borgesian account, how much this story has become a myth of western culture.[38] In 1976 the English popular science fiction writer Brian Aldiss incorporated the invention in his fantasized history of Dalmatia, *The Malacia Tapestry*. In a 1989 largely fanciful biography of Niépce by the former actress Odette Joyeux, the literary invention of photography would come full circle with the unwarranted claim that the young Niépce's researches were inspired by reading the fantasy novel *Giphantie*.[39] More broadly speaking, many literary speculations on the significance of photography for cultural history have emphasized, explicitly or otherwise, a contrast between it and the older, written culture (as in the case of Daniel J. Boorstin's 1961 jeremiad on 'the image'). A few critics, though, citing early hybridizations of photography and language in cinema or advertisement, have chosen instead to highlight the alliance of modern images with writing, the American poet Vachel Lindsay marvelling in 1916 at a new 'hieroglyphic' civilization.[40] Incidentally, the photography of writing, especially public, was an important thread of modernist and later avant-gardes, as well as a significant documentary practice; since 1970 writing and photography have been closely allied in various artistic practices, whether narrative, fictional, or polemical.

In concluding this chapter, however, I would like to remain focused on the 1939 contest between François Arago and William Henry Fox Talbot. Both scientists recorded the invention of photography in writing and in narrative form, as experience and event, and both acknowledged its links to (various) literary genres, concerns, and tastes. Yet their formulations of the invention itself were diametrically opposed, and not just because of nationality. The two scientists actually configured two photographies, and two relationships of photography to literature. While Arago's master narrative would gain influence over much of the social usage and later historiography of the invention, Talbot's singular emphasis on photography as experience, and indeed, as we shall see in the next chapter, as expression of the self, would ultimately prove the

more relevant to the artistic development of the medium in the twentieth century. When the inventor of the calotype chose to illustrate his practice and his conception of photography in a book, especially, he was anticipating an alliance between photography and literature that many would later regard as natural.

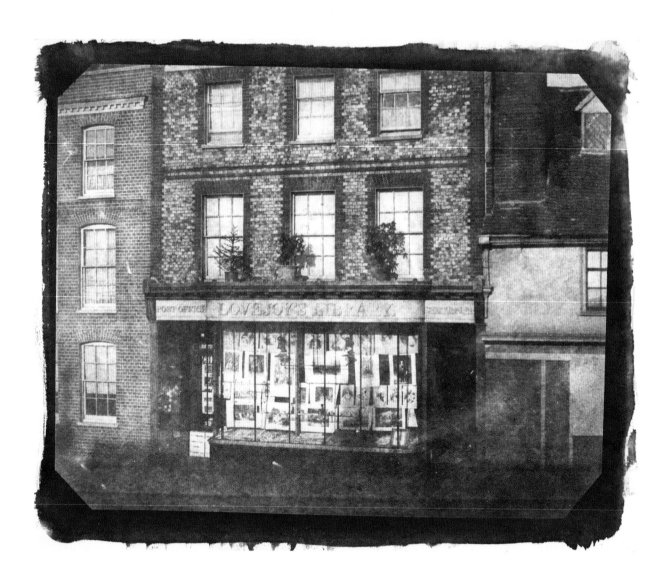

two

Photography and the Book

If I could do it, I'd do no writing at all here. It would all be photographs.
James Agee, *Let Us Now Praise Famous Men*, 1941[1]

Although photographs have long hung on the walls of museums, many of photography's most remarkable achievements and more ordinary productions were designed for and published in books. Much of the photography that was produced in the nineteenth century, at least much of the ambitious, large-size photography that is prized today, was created with the earlier model of prints and large books or albums in mind, and often intended to serve as illustration, even when exhibition was also envisioned. Carte-de-visite portraits as well as larger views, publicly displayed in galleries, studios and booksellers' windows, were collected in albums that looked like thick books and were kept on bookshelves. Books were commonly used by portraitists as props, conferring status on their subjects, and derided as such in caricature. Such facts might be considered symptoms of photography's original subjection to 'literature' or written culture, and the redefinition of photography as art construed as evidence of 'the library' realigning itself with 'the museum'.[2] However, careful examination of the history of photography suggests that the photographic book has been not only one of the medium's foundational projects but one of the primary means of its cultural recognition. As Martin Parr and Gerry Badger have shown in their imposing survey, since 1839 vast numbers of photographically illustrated books have been produced, and the 'photobook' – once envisioned solely as a prized incunabulum[3] – must be considered the medium's premier mode of circulation, combining mass

16 Nicolaas Henneman, *Lovejoy's Library (in Reading)*, c. 1844–7, calotype paper positive.

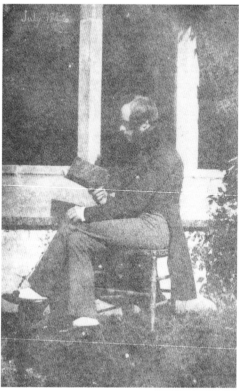

distribution and creative expression.[4] All the while, a major – yet usually overlooked – paradox of this history is that the photographic book remained for the longest time a technological oxymoron.

I begin this chapter by exploring this paradox, looking at how the photographic book was both a guiding concept and a technical impossibility and addressing its first major resolution at the hands of Talbot. It was he who inaugurated, most concretely and brilliantly, photography's alliance with the book and thereby the figure of the photographer as author. I then follow some of the various paths taken by photographic publishing out of this model, predominantly scientific and archival in the nineteenth century, later increasingly literary and self-consciously photographic. My goal here is not an analytical description of the photo-book's infinitely varying formats and formulas,[5] but rather an outline of a cultural

17 Marcus Root, *Unidentified Woman, Half-length Portrait, Facing Left, Seated Holding Book*, c. 1846–56, sixth-plate daguerreotype.

18 W.H.F. Talbot, *Nicolaas Henneman Reading*, c. 1843, paper positive from calotype negative.

history that, in my view, has definitively validated Talbot's inspiration in *The Pencil of Nature* in firmly establishing the authorship and authority of the photographer.

The Pencil of Nature, published by instalments between 1844 and 1846, was among other things a daring, if imperfect, solution to a dilemma that plagued not only Talbot, but before him Nicéphore Niépce – and that continued to inform much of photography's technological development through the nineteenth century and beyond. Both Talbot and Niépce had explicitly envisioned their inventions as tools for copying and/or printing. Niépce's heliography was originally designed for and applied to the reproduction of lithographs. Talbot's various processes, especially the early photogenic drawing, were considered by him methods of copying, reproducing, printing and publishing, as much as tools for drawing or making pictures; in the 1840s and '50s he perfected various methods of 'photographic engraving'.[6] In itself, his choice of paper as base, rather than metal, reflected his conviction that photographs

19 Cover of W.H.F. Talbot, *The Pencil of Nature* (London, 1844–46).

20 W.H.F. Talbot, 'Fac Simile of an Old Printed Page', plate IX of *The Pencil of Nature*; paper positive from calotype negative.

belonged in the twin traditions of print and sketch. In 1839, as we have seen, he was playing with the (democratic) slogan 'every man his own printer and publisher'; this was made visible, in *The Pencil of Nature*, by several plates presented as facsimiles of printed text or picture, or the photogenic copy of a leaf.

Yet Talbot's achievement in this relatively elitist publication[7] was eclipsed by the daguerreotype's success, which popularized Daguerre's taste for the picture as self-contained object and semi-autonomous spectacle. In spite of its name, the daguerreotype was anything but a printing technique, and it established photography as a technology of imaging, rather than one of printing. Through the nineteenth century and even beyond, photography, in its broad social uses, estranged itself from the twin logics of reproduction and publishing. Despite many inventive efforts and some breakthroughs, such as carbon printing or the heliotype and collotype processes, the technological gap that separated photographs from their printed reproductions endured at least until the advent of half-tone printing and photogravure in the late nineteenth century. Until then, the social life of photographs was largely limited either to private uses or to luxury editions with tipped-in photographic prints, while images remained mediated, for the most part, by engraving and lithography.[8] Even after half-tone, for much of the twentieth century, the photographic quality of photographs was – especially in colour – rarely matched in print. Thus the functional unity of picture and printed page that served as one foundation of photography – as envisioned by Talbot and, to a lesser degree, by Niépce – was only achieved in practice a short time before it was displaced as a desirable goal by the advent of digital photography and screens as primary carriers of images.

The Pencil of Nature was, by contrast, the first 'photographic book' and as such would become a milestone – despite its limited circulation. With its large plates, many devoted to picturesque or artistic subjects, and its format combining image, title, and extended caption, it was reminiscent of the sketchbook and the artist's book. The more established interpretation of Talbot's photographic work in *The Pencil of Nature* has emphasized its links to the 'pictorial tradition' of the medium.[9] Indeed Talbot took pains to emphasize, in the introductory texts, that he

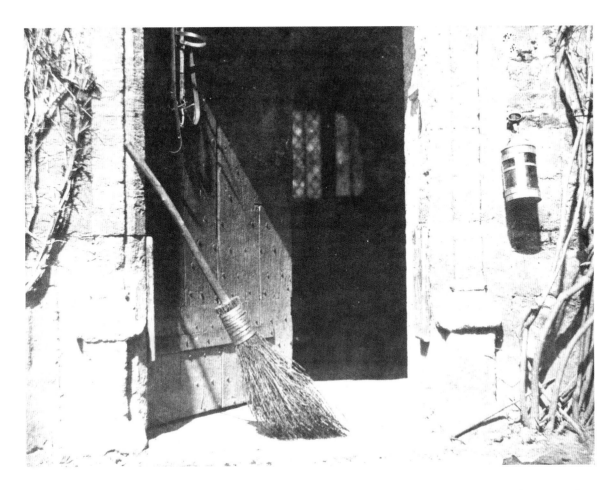

21 W.H.F. Talbot, 'The Open Door', plate VI of *The Pencil of Nature*, paper positive from calotype negative.

regarded his book as 'the first specimen of the [new] art' of photography, an art whose inception he situated in his own failed attempts at sketching with a *camera lucida* at Lago di Cuomo in 1835. Many of his iconographic choices, and some remarks in the captions, point to his desire to emulate painting – one example is his reference in the caption for Plate VI, 'The Open Door', to the 'Dutch school of art' as a justification for the choice of 'scenes of daily and familiar occurrence', such as a shadow or a gleam of sunshine awakening 'a train of thoughts and feelings, and picturesque imaginings'. The name he finally adopted for his perfected paper negative process, *calotype*, was based on *kalos*, meaning 'beautiful' as well as 'good'.

As Hubertus von Amelunxen has noted, however, *The Pencil of Nature* was also 'the first meeting of photography and writing', and not just because it juxtaposed photographs and texts.[10] Much in the book suggests that it (along with its twenty-four plates) was an experiment in an 'art' that was envisioned not only as a companion to painting or watercolour – nor, strictly speaking, as a purely visual medium – but also as a broader, relational creative practice engaging images and words, seeing and reading, picturing and writing/printing, light (or shadow) and ink. Various clues point to a utilitarian reading of this association – *The Pencil of Nature* has often been described as a catalogue of the future uses of photography – but there was more to it. Talbot inscribed a copy of the book with the annotation 'words of light', a biblical echo that defined the natural pencil as a dialogic tool, a bipolar medium in which nature served as a field of projection for the self – and therefore allied photography with the (Romantic) project of literature, more crucially than it placed it under the aegis of painting or, for that matter, in the merely functional framework of publishing.[11]

The aesthetic ambition of the project was declared by its epigraph, a quote from Virgil's *Georgics* signifying an artist's aspiration to 'plough a new field'. Coupled with Talbot's name and titles, this reference openly announced an author's persona, abundantly echoed by the recurring first person pronoun in the preliminary texts and the captions, and conflicting at least in part with the caveat that 'the plates of the present work are impressed by the agency of Light alone, without any aid whatsoever from the artist's pencil'. Although this author consistently presented himself as a mere commentator of 'self-representations' (as in his caption to Plate xv, a view of his mansion, Lacock Abbey, said to be the first building 'yet known to have drawn its own picture'), many of his comments – along with the very mechanism of commentary – evinced the persona of an artist or rather a writer, lending sense (or mystery) to the plates. The caption to Plate iii, 'Articles of China', juxtaposed a eulogy of the ease of reproducing photographically the 'strange and . . . fantastic forms' of old teapots with the fictional conjecture, 'should a thief afterwards purloin the treasures', that the 'mute testimony of the picture' might be 'produced against him in court'. The famous Plate

22 W.H.F. Talbot, 'Lacock Abbey in Wiltshire', plate XV of *The Pencil of Nature*; paper positive from calotype negative.

VIII, 'A Scene in a Library', is of course the classic representation of photography's alliance with literature – and not just because, like several other Talbot photographs, it depicts books on shelves. The image is a brilliant exercise in the interplay of light and shadow as the constituent language of photography; a flat, frontal and tabular composition reminiscent of a book page, it suggests an analogy between the individualization of the various books standing against a shadowy background and the reading of their titles, gleaming against dark labels on the embossed bindings. Moreover, as in Plate III, the caption adjoins to the image a fictional 'experiment or speculation' – this time, however, apparently wholly unrelated – proposing to transform an 'apartment' into a giant *camera obscura* and, allowing only the 'invisible rays' to pass into it, to have a (photographic) camera record the 'portrait' and 'actions' of persons placed in the dark room and invisible to one another. The photographic author concludes:

> Alas! That this speculation is somewhat too refined to be introduced with effect into a modern novel or romance; for what a *dénouement*

41

23 W.H.F. Talbot, 'A Scene in a Library', plate VIII of *The Pencil of Nature*; paper positive from calotype negative.

we should have, if we could suppose the secrets of the darkened chamber to be revealed by the testimony of the imprinted paper.

As in Plate III, this speculation can be read as a prophecy of photo-surveillance; but it is written as fiction, with explicit reference to the code of the (detective) novel, and the juxtaposition of the image of books on shelves with the textual appeal to 'the testimony of the imprinted [photographic] paper' creates a reflexive reading, a 'self-representation' of photography as an art of the book, a highly self-conscious practice of writing and reading.

In Plate X, 'The Haystack', justly celebrated as one of Talbot's most spectacular successes, the caption foregrounds the 'Photographic art' as one enabling 'us to introduce into our pictures a multitude of minute details . . . which no artist would take the trouble to copy faithfully'. Such 'minutiae', Talbot insists, will 'sometimes be found to give an air of variety beyond expectation to the scene represented'. Photography, then, implements the improbable marriage of absolute identity and unpredictable variety, a form of representation 'beyond expectation' that

24 W.H.F. Talbot, 'The Haystack', plate X of *The Pencil of Nature*; paper positive from calotype negative.

resonates deeply with the modern (and postmodern) imagination.[12] The same passion for charting the unexpected inspires the caption to Plate XIII, 'Queen's College, Oxford, Entrance Gateway', where critics have rightly noted the first formulation of what Walter Benjamin later called the 'optical unconscious':

It frequently happens, moreover – and this is one of the charms of photography – that the operator himself discovers on examination,

43

perhaps long afterwards, that he has depicted many things he had no notion of at the time. Sometimes inscriptions and dates are found upon the buildings, or printed placards most irrelevant, are discovered upon their walls: sometimes a distant dial-plate is seen, and upon it – unconsciously recorded – the hour of the day at which the view was taken.

This 'unconscious recording', which decisively distinguished photography from painting, also signalled it as an exercise of self-discovery that strongly allied it with reading and more generally literature as the cultivation of the self.

Although a few of the plates in *The Pencil of Nature* reverted to scientific imagery and others inscribed an explicitly artistic heritage, the book as a whole can hardly be read either as a work of science or art in any traditional sense. Instead it deploys itself as a self-representation of photography, its applications and possibilities, and its inventor's voice – thereby associating the allegedly neutral 'pencil of nature' with the singular vantage point of a photographic author and aligning the 'art' of photography with a rhetorical if not a literary project. Considering the extraordinary expressiveness that Talbot thus associated with the photographic book, it is striking that in the following decades – and even into the twentieth century – this epochal book was rarely imitated, and did not function as a model, except formally. Talbot's second 'photographic book', *Sun Prints of Scotland* (1845), though based on the works of Sir Walter Scott, was a specialized application of the broad programme outlined in *The Pencil of Nature*. More object-bound, thematic, more 'picturesque', and less reflexive, it prefigured Talbot's and his Reading Establishment's later productions, which were more narrowly documentary (though his brochure of 1846, *The Talbotype Applied to Hieroglyphics*, reflected again photography's deep-seated connection to writing). Thus *Sun Prints of Scotland* inaugurated the dominant model of the nineteenth-century photo-book, which was usually geared at illustration and collection, rather than conceptual exploration of photography. As Nancy Armstrong and others have shown, photographically illustrated books most often arose, in the nineteenth century, from scientific or documentary projects. Most

25 Plate I, heliotype reproductions of photographs from the second edition of Charles Darwin, *The Expression of the Emotions in Man and Animals* (London, 1873). Photos 1, 3 and 4 by Oscar Rejlander, photo 2 by Adolph D. Kindermann.

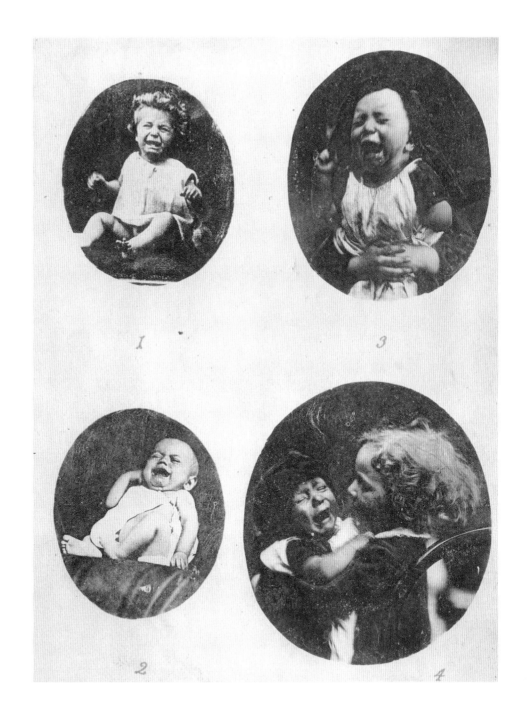

1 *3*

2 *4*

of the hundreds of photographic books, albums, and portfolios published in the second half of the nineteenth century followed the technical formula established by *The Pencil of Nature*. That is, they combined printed text with tipped-in photographic prints in productions usually costly, luxurious, and limited; this was for the purposes of thematic illustration or encyclopaedic collection, however, and did not emulate *The Pencil of Nature*'s reflexive insights into photography and photographer.

This vogue for the photographic book was, in fact, only a facet of a broader expansion of printed visual culture, fostered by the publishing industry's growth and the increasing demand of scientists for illustration, which yielded thousands of volumes illustrated with lithographs, chromolithographs, or wood and steel engravings, based or not on photographs. From the 1850s onwards photography and photographic illustration became standard accessories in an increasing number of investigations in anatomy, physiology, psychiatry, anthropology, or criminology; series of photographs commissioned specifically were published in scientific treatises, such as Charles Darwin's *The Expression of Emotions in Man and Animals* (1872), which included seven pages of photographic portraits of 'emotions' reproduced in heliotype, 'much superior for my purpose', stated Darwin, 'to any drawing, however carefully executed'.[13] Here the documentary function and the serial nature of the material – rather than any 'literary' goal – justified the book format and the inclusion of large numbers of plates in a book. Thus the main avenues of photographic book publishing in the nineteenth century were scientific, especially anthropological, geographical, or antiquarian, and (more so after 1870) promotional or commercial; they were not artistic, literary, or 'photographic' in the reflexive sense so skilfully displayed by the *The Pencil of Nature*.

This is not to say that among these early photographic books there were no attempts at style or expressions of authorship. Some of the earliest and most memorable photographic enterprises of the nineteenth century, especially in the field of travel and exploration, were the work of amateurs (and some professionals) working, if not independently, at least away from formal academic or governmental contexts. During the first decade of the daguerreotype and the calotype era, pioneering

26 A George Wilson Bridges, *St Nicolo's convent and chapel, Mount Etna, Sicily, Italy, 1846*, paper positive from calotype negative.

photographic ventures were carried out by literati and independent travellers working within the tradition of the sketchbook. Among early publications with illustrations based on daguerreotypes one may quote Noël Lerebours's *Excursions daguerriennes* (1842), John L. Stephens's and Frederick Catherwood's *Incidents of Travel in Yucatan* (1843), or Henry Mayhew's *London Labour and the London Poor* (1850). As is well known, the calotype's 'golden age' – the 1850s – was marked in France by a boom of photographic projects and publications, usually albums, many of which were produced by Louis-Désiré Blanquart-Evrard's printing establishment (1851–5).[14] In 1852 the writer and critic Maxime du Camp published a photographic album with 125 views, *Egypte, Nubie et Palestine*,

issued by instalments like *The Pencil of Nature*. It was one of the very first such books on the Middle East, recounting his travels there in 1849 in the company of Gustave Flaubert. Significantly, Du Camp did not make use of, or reference to, Flaubert's literary skills, and reserved his own fictionalizing narrative for a later volume.[15] This was nonetheless a precedent to a host of Oriental travel albums, including Francis Frith's widely acclaimed album *Egypt and Palestine* (1857), which inaugurated commercial exploitation of Oriental photography.[16]

Frith, one of the first to adopt the collodion process, was also more explicit than many in defending photography as an art of its own, and spelling out his ambitions. Arguably it was with him that the photo-book or photo-album, sometimes embellished by literary adjunctions, became a conscious medium for exposing and promoting photographic achievements. Examples of professional photographers who boosted their own careers in this fashion include Francis Bedford (who contributed several photographs to *The Sunbeam*, a photo-literary album juxtaposing prints with pages of poetry or prose edited by Philip H. Delamotte and published in book format in 1859); Désiré Charnay (*Cités et ruines américaines*, 1862); the Corfian Felice Beato with his volumes of

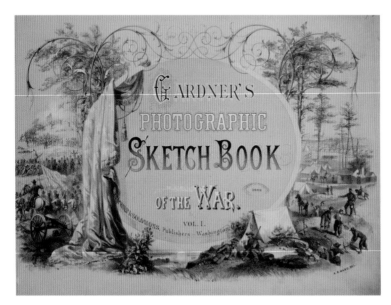

27 Engraved title-page for Alexander Gardner, *Gardner's Photographic Sketchbook of the War* (Washington, DC, 1866).

views and 'native types' of Japan (1868); or the Scots-American Alexander Gardner, who, after breaking away from Mathew Brady, made a conspicuous statement of photographic authorship in his *Gardner's Photographic Sketchbook of the War* (1865). Closely related to these voyagers to exotic lands were early explorers of city life – some commissioned and some not, but generally publishing their work in the form of books or albums – such as Charles Marville (in his series known as 'Album du vieux-Paris'), Thomas Annan (*The Old Closes and Streets of Glasgow*, originally published as a photographic album in 1872) or John Thomson (*Street Life in London*, 1878, also published in instalments).

It would be an oversimplification to contrast the nineteenth century's passion for collecting, classifying and cataloguing with a later phase supposedly privileged with the liberation of subjective photographic energies and expressions. There were significant works by self-conscious author-photographers in the nineteenth century, and conversely the culture of archiving did not vanish in the twentieth, as shown by the us Farm Security Administration's immense photographic coverage of the Depression. Still, the Victorian craze for photographic surveys resulted in associating the *The Pencil of Nature*'s format with utilitarian concerns rather than aesthetic ones. In the nineteenth century, the dominant function of photographic publishing was documentation, whether scientific, historical, or commercial; its main operative mode was the survey or the archive; and its main product was the book or album, often large and expensive. For the same reasons, these photographic books were more often than not the result of collaborations – or mere contracts – involving hired professional photographers who, serving illustrative goals, were generally not in a position to express authorial concerns. Thus the survey of French historical monuments known as the Mission Héliographique, though it launched the careers of Gustave Le Gray and other giants of the 'French calotype' era and set a model for later surveys of various kinds, subordinated the photographers' activity to an archival logic.[17] A decade or so later, and partly in reference to this model, a flourishing of 'landscape' and 'Indian' photography took place in the American West, largely connected to a surveying boom sponsored, for economic and political

reasons, by Federal, state, or corporate entities and directed by scientists or military personnel. The many photographic books and albums produced in this context, though they usually credited the photographers, aimed at drawing attention to their scientific or military sponsors, who distributed them with a view to prestige.[18] Around 1870, in an era of 'boosterism', photo-books of the American West became a favourite genre among explorers, railroad magnates, mining or logging concerns, and western politicians. These fancy productions, though they incorporated a vague discourse of photographic authenticity (opposed to the falsity of 'tall tales'), more often than not enlisted their photographs in the service of legend, as Martha Sandweiss has shown.[19] In some of the more demanding ones, much rhetorical energy was spent in describing the pictures, their eloquence or their 'effect'.[20] As a rule, however, such publications showed little care for issues of authorship or style (often images were bought and sold, pirated, or republished under different names). If they registered what would qualify today as photographic concerns, these were subtly embedded in the images themselves, rather than voiced out loud.

To take one example that has become classic, the survey photography of the Irish American Timothy H. O'Sullivan – which was published in several albums for two western surveys, and also served as the basis for many of the lithographs contained in their reports – unquestionably incorporated reflexive aspects, even authorial hints. O'Sullivan never put these in words, however, and it was instead his employer, the high-profile geologist Clarence King, who came closest to expressing the aesthetic – indeed the literary – appeal of O'Sullivan's 'views'.[21] Meanwhile, O'Sullivan's taste for flat, planar compositions, sometimes described as a pre-modernist feature, is more convincingly interpreted as obeying the format of the book, the map, or what Robin Kelsey has termed an 'archive style'.[22] Even when photographers were employed by artists, the survey structure tended to preclude the verbal expression of a photographic discourse. In what is perhaps the most formidable example of such collaborations, William Bradford's *The Arctic Regions* (1873), a colossal folio volume illustrated with some 140 albumen prints from negatives by John L. Dunmore and George Critcherson, Bradford's highly sophisticated

28 Timothy H. O'Sullivan or Andrew J. Russell, *Facilis Descensus,' portrait of Clarence King*, 1868; albumen print.

layout went very far – farther than most photo-books – in forging a dynamic relationship between text and pictures; but it did not offer much of a reflection on photography. Even silent, however, such collaborations were desirable for ambitious professional photographers, because they represented a unique chance not only to do landscape or outdoors work away from the more mundane demands of the market, but also to see it published in a prestigious fashion, thus adding a 'literary' label to a commercial career.

of che-
estroyed.
vetter, if
s it was
n to re-
photo-
t to an-
e effort
sful.
nproved
up the
way to
ation at
glacier,
as we
e possi-
matter
roes or
. The

No. 33. SIDE VIEW OF THE FRONT OF THE GLACIER,
ABOUT 100 FEET ABOVE THE WATER.

were hi
other, bu
and ther
land be
shore w
places
densely
all the
Arctic
and casc
pouring
ing sno
astern w
feet wid
gorge w
at an an
grees. T
sequently
origin in

ur second anchorage we witnessed one of Nature's throes, technically to
a large section from the glacier, which then becomes an iceberg.
l a premonitory growl or moan. This is generally given forth by the
surplus ice, and attention was immediately directed towards the point from
o say, no disruption appeared in progress. One of the highest peaks of

No. 34. ONE OF EIGHT IMMENSE ICEBERGS, WHICH WERE DISCHARGED FROM THE FRONT
OF THE GLACIER WITHIN FIVE MINUTES. THIS WAS GROUNDED IN NEARLY 500 FEET
OF WATER. THE LARGE MASSES SEEN ON THE SIDE NEAR THE WATER, SOME OF THEM
FIFTY FEET THROUGH, WERE CAUGHT AND REMAINED IN THIS POSITION, WHILE THE BERG
WAS ROLLING.

Although it would seem that this type of ambitious collaborative effort between photographers and scientists declined after 1900, things are not so clear-cut. First of all, the complex technological mutation sometimes called the 'graphic revolution' transformed, between 1880 and 1920, the whole economy of photography and illustrated publishing. With the advent of cheap and easy amateur equipment, scientific and archival projects increasingly relied on their own resources – or on 'house photographers' – for taking pictures (and movies), as, for instance, in anthropology. Travel narratives illustrated and published by tourists became banal, as well as trade albums, calendars, pamphlets of all kinds; also numerous in this period were historical and art-historical surveys illustrated with photographically-based reproductions. Indeed this shift was seconded by the rise of reliable photomechanical processes, whether cheap and popular (half tone) or expensive and elite-bound (photogravure), which progressively eliminated the traditional 'photographic book' and made photographically illustrated publishing more accessible. Perhaps most importantly, technological change was paralleled by a social transformation that, in the industrialized world at least, made photographs – and pictures more generally – at the same time more ubiquitous, more culturally significant and more semantically autonomous. As we shall see in the following chapters, writers from Marcel Proust to James Joyce recorded this new phase in the expansion of 'visuality', while some of them acknowledged photography's new artistic and cultural powers by incorporating photographic illustrations in their work; this was also the period when photographers started to write more freely about their art and its transformation into a full-fledged medium.

American photography of the 1900–1920 period gives us three important examples of this transformation, which saw individual photographers take at least partial responsibility for big projects, whether 'documentary' or 'artistic', that resulted in large-scale publications. These were Alfred Stieglitz's direction of the magazine *Camera Work* (1903–17), which published artwork as well as literature and criticism and was intended as an observatory of modern art; Lewis Hine's work for the National Child Labor Committee and the Pittsburgh Survey, which, inspired by the earlier example of Jacob Riis, explicitly enlisted

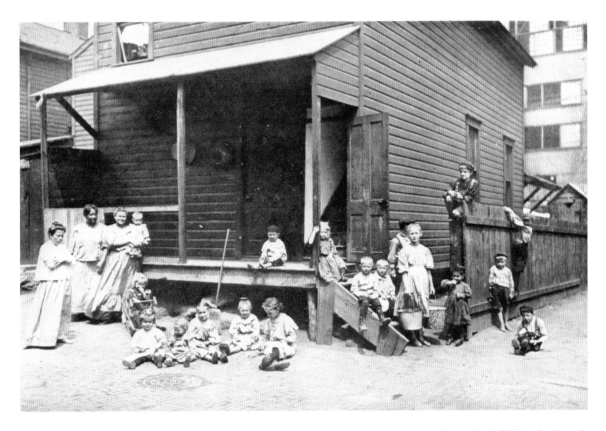

31 Lewis Hine, 'Spontaneous Recreation Center, Homestead, 1907', half-tone reproduction in Margaret Byington, *Homestead: The Households of a Mill Town*, vol. IV of *The Pittsburgh Survey* (Pittsburgh, 1911).

photography and sociology in the services of 'social uplift';[23] and Edward S. Curtis's monumental survey of Native American cultures (published between 1907 and 1930 as *The North American Indian*), which merged the commercial photographer's viewpoint with anthropological and memorializing concerns, as well as a strong sense of aesthetics.[24] It would not be long before the identification of potential archival projects would become the acknowledged prerogative of photographers themselves, within or outside of organizational frameworks. Such projects have been undertaken throughout the twentieth century, among them August Sander's 'People of the 20th century', of which he was able to publish only a selection (in *Antlitz der Zeit*, 1929); Walker Evans's *American Photographs* (1938); W. Eugene Smith's Pittsburgh project (1950s); Berndt and Hilla Becher's survey of industrial architecture (1960s); and the

French government's 'Mission photographique de la D.A.T.A.R.', a postmodern resuscitation of the survey model, which was led by photographer François Hers in the 1980s and eventually published in 1991 in an oversized and expensive book.

In the interwar period, the so-called 'documentary' genre (probably better understood as a 'style', following Walker Evans's phrase)[25] largely identified itself with the emergence of the 'photo-essay'. This was a new publishing form as well as a new discursive space for photography, the origins of which historians locate in the late Weimar Republic (with August Sander, but also Albert Renger-Patzsch and Franz Roh).[26] After Weimar, and before New York, Paris was, in the 1930s, a major subject and publishing centre for this trend, though in a more apolitical vein. Examples of key texts of the period include *Atget photographe de Paris* (1930), Brassaï's *Paris de nuit* (1933) and *Paris vu par Kertesz* (1934). The photo-essay could be seen, on one level, as adapting the earlier pattern of the survey to the emerging taste for photography of the literary and cultural avant-gardes after World War I, as in László Moholy-Nagy's 'new vision'. In the Soviet Union, the photographer Alexander Rodchenko collaborated simultaneously on an illustrated edition of Vladimir Mayakovsky's poetry and on various publishing projects, including the radical magazine *USSR in Construction*. It is tempting to suppose that 'serious' or 'creative' photographers (who in the nineteenth century would most likely find publishing outlets in scientific or archival

32 Photography and layout by Alexander Rodchenko for a 'Mayakovsky' special issue of *USSR in Construction* (1940).

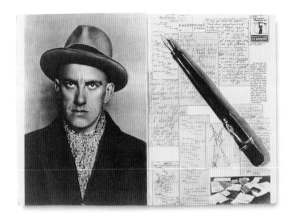

ventures) became all the more prone, in the twentieth, to associate
themselves with writers, since the latter were often drawn to incorporate
photographs in their published work. In chapter Five we will discuss
some examples of photo-literary projects in this period, from Henry
James's collaboration with Alvin Langdon Coburn to André Breton's
illustrated novel *Nadja*.

The rise of the photo-essay, on the other hand, was largely conditioned
by that of the mass picture magazines, which in some cases pre-published
photographic projects, but also by avant-garde illustrated magazines
and collections, as was the case in the Soviet Union and later with the
Paris School. The significance of graphic design and layout, set forth by

the Bauhaus and relayed in the USA especially by Alexey Brodovitch, was henceforth a basic premise of photo-publishing. Most importantly, photo-essays, as they developed around 1930, often deviated from the earlier archival, positivist model (along with the traditional subjection of image to text) and tended instead to read as 'polemically constructed photographic arguments',[27] often framed by photographers themselves from a militant point of view. Their rise owed much to the Great Depression and its heightened political mood, especially in Germany, the Soviet Union, France, and the US, although in the latter country the Farm Security Administration's large-scale documentation and propaganda effort produced mostly milder and more seemingly 'neutral' works. Between 1933 and 1945, approximately fifteen to twenty such photo-essays were published in the US, unquestionably climaxing with the monumental *Let Us Now Praise Famous Men* (1941), co-authored by Walker Evans and James Agee (but overlooked until the 1960s, while *Many Are Called*, Evans's reportage on New York subway passengers prefaced by Agee, would only appear in 1966).[28]

According to Agee's highly paradoxical dialectics, the text and pictures of *Let Us Now Praise Famous Men* were meant to be 'mutually independent'; and the reader could find no ready connections between Agee's winding prose and Evans's stark images in the portfolio section. The placement of the photographs, uncaptioned and unnumbered at the front of the book, their silent sequence constituting in fact a separate 'Book One', was a formal 'anomaly' that pointed to a 'mediamachia', in Peter Cosgrove's terms – a battle between picture and text.[29] This even as Agee, in superlative modernist style, multiplied his expressions of the writer's aspirations to stylelessness, disembodiment and deference to the camera's absolute, mechanical realism. Stating, 'If I could do it, I'd do no writing at all here. It would all be photographs', the writer was suggesting that the emergence of a language of photographic images – moving pictures included – was destined to bring about the demise of traditional literature (or writing). *Let Us Now Praise Famous Men* contained approximately 400 pages of text by Agee, but the photographer's pictures and Agee's description of them tended to make Evans the fundamental author – merging authorship and authority. According to Agee it was the images

34 Walker Evans, *Allie Mae Burroughs*, 1935/6, gelatin silver print in album. This image was used as one of the illustrations in James Agee's and Walker Evans's *Let Us Now Praise Famous Men* (Boston, 1940).

that were the true source and expression of the 'anti-authoritarian consciousness' he sought to reveal; his role was reduced to that of a commentator. In this sense, *Let Us Now Praise Famous Men* came perhaps closest to echoing the distant model of Talbot's *The Pencil of Nature*, and established – or would establish in retrospect, after being rediscovered in the 1960s – the new conceptual eminence of the photographer as both anti-writer and super-author.

Walker Evans's resolute posture of silence – not only in *Let Us Now Praise Famous Men* but in most of his publications – contrasted vividly with the narrative and rhetorical modes that characterized other stages of photography's emancipation, which I will discuss in chapter Four. Along with the more strictly reportorial mode associated with Magnum photographers, it consolidated a 'documentary style' that in the following decades would become identified with the format of the sober, wordless, layout-dense photo-book. Prime examples of this format would be, in the 1950s, William Klein's book on New York (1955) and Robert Frank's *The Americans* (1958), both initially published in France.[30] Jack Kerouac's short preface to Frank's book decisively sanctioned the newly subservient role of writers in an emerging *auteur* model of photography. Before closing this chapter, however, I must stress that in tracing the history of the photo-book from the point of view of photographic authorship I have evidently left out not only more strictly literary uses of photography (to be discussed in chapter Five) but other avenues besides those espoused by a fairly academic lineage of 'serious' or 'creative' photographers.

Commercial photographic publications (not to mention photographic mail-order catalogues, directories, yearbooks, etc., were legion in the twentieth century, some contracted to renowned photographic artists (especially in fashion and advertising), and some, particularly after 1960, following and capitalizing on the increasingly highbrow model of the photographic *auteur* and the documentary photo-book. Parallel to the rise of this model was the emergence of popular forms of photo-fiction, such as *roman-photo* (perhaps better known in Latin countries), a variant, often sentimental, of the comic strip with photographs in lieu of drawings. This popular genre significantly perpetuated a transitive, referential, narrative, and above all un-authored form of photography coupled with the heritage of pulp fiction

35 Leslie Scalapino, 'they backed up the bully . . .', photo-poem, c. 1992, also reproduced in black-and-white in *Crowd and Not Evening or Light* (Oakland, CA, 1992).

36 Leslie Scalapino, '(they) like reality / as a function . .', photo-poem, c. 1992, also reproduced in black-and-white in *Crowd and Not Evening or Light* (Oakland, CA, 1992).

– even as authors' photo-books were becoming acceptable coffee-table displays. Aestheticization would eventually affect these popular genres as well – from *roman-photo* to mail-order catalogue – as part of a broader reclaiming of popular culture by avant-gardes, the art market and the academy. But these later developments subsumed another epistemic shift which after briefly touching upon I must now address more squarely – the discovery of photography by writers of literature, which as we will see is not an isolated moment but an ongoing process, the accumulated result of which has been tremendously influential in the legitimization of photography.

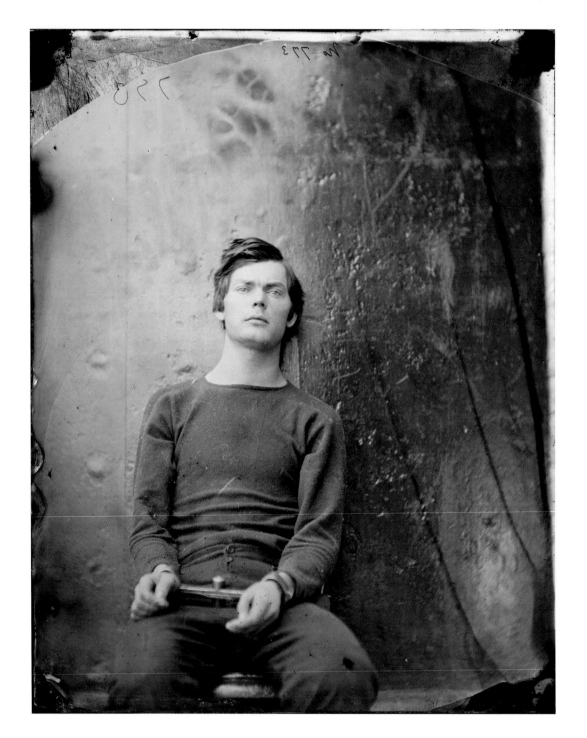

three
Literary Discoveries of Photography

'[Think of] the fact of the very shadow of the person lying there fixed for ever! It is the very sanctification of portraits I think and it is not at all monstrous in me to say what my brothers cry out against so vehemently . . . that I would rather have such a memorial of one I dearly loved, than the noblest Artist's work ever produced.'

Elizabeth Barrett Browning to Mary Russell Mitford, 1843.[1]

In 1980, as several anthologies of essays on photography were published in an effort to remedy what Alan Trachtenberg called the lack of a 'critical tradition',[2] the appearance of Roland Barthes's *Camera Lucida (La Chambre Claire)* almost single-handedly created such a tradition.[3] Setting out to discover 'the essence of photography', the French critic claimed to find it in the inescapable connection of the photograph to reality – or past reality: 'that has been' was for Barthes the photograph's conceptual name. For Barthes, this (chemical) connection radically distinguished the photograph and its 'certifying' power from other kinds of images. Along with the distinction between *stadium* (the studious response to a picture's declared subject) and *punctum* ('pricking' caused by the confounding hyperrealism of a marginal, unintentional detail), this description of photography's superior 'referential' power was phrased as a statement of *love* for photography – and against painting, literature, cinema, artful representation in general. Eager to uphold the primitive amazement of looking at an 'emanation' of reality against increasing sophistication of the medium and scepticism about its 'natural' status, Barthes offered sensational discoveries: 'he is dead and he is going to die.'[4]

37 Alexander Gardner, *Portrait of Lewis Payne in Washington Navy Yard, DC*, April 1865. This was used as illustration in Roland Barthes' *Camera Lucida.*

Enfant, je m'ennuyais souvent et
beaucoup. Cela a commencé visiblement
très tôt, cela s'est continué toute ma vie,
par bouffées (de plus en plus rares), il est
vrai, grâce au travail et aux amis), et cela
s'est toujours vu. C'est un ennui panique,
allant jusqu'à la détresse : tel celui que
j'éprouve dans les colloques, les conférences,
les soirées étrangères, les amusements de
groupe : partout où l'ennui peut se voir.
L'ennui serait-il donc mon hystérie ?

28

Détresse : la conférence.

Ennui : la table ronde.

Coming from France's foremost literary critic and promoter of 'literariness' (who had early on demonstrated an interest in images) and followed as it was by its author's untimely death, *Camera Lucida* came to be regarded as a paradox, a critic's testament, and a work of mourning. Indeed, in the book the essayist's discourse was deeply anchored in the subjective point of view of the *Spectator* (affecting indifference to the *Operator*) and constantly underwritten by an autobiographical, emotional, nostalgic voice. One of the recurring motifs of Barthes's exploration was his own image, an alien or alienating image, demonstrating 'the advent of myself as other'. In the second part, the insistent argument on photography's links to the past, death, and memory was grounded in the melancholy narrative of Barthes's search for a satisfactory photograph of his recently deceased mother. Though the book was illustrated with a number of (well-known) images, this private picture, which Barthes claimed to have eventually found, was not inserted; its looming absence conferred to *Camera Lucida* an elegiac and vaguely mysterious mood. Thus *Camera Lucida* could be read – especially in the wake of *Roland Barthes par Roland Barthes* – as an essay on photography, a photo-essay, a personal album, and an autobiographical *roman-photo*.[5]

Bypassing the tired debate on photography's place between 'science' and 'art', the book established its deeper ambivalence between reality and fiction, objective and subjective, public and private, thereby echoing contemporary creative trends which I will turn to in chapters Four and Five. In this chapter, however, I choose to read Barthes's essay as a recapitulation of a century and a half's history of *literary discoveries of photography*. Taken as a piece of 'serious writing', *Camera Lucida* did not, in fact, have much to say about the 'essence' of photography that had not appeared many times before in what Trachtenberg called the 'record of *thinking* about the medium'. This is a rather considerable record, where literary commentaries come foremost – from Edgar Allan Poe to Paul Valéry, Charles Baudelaire to Walter Benjamin, Lady Eastlake to Susan Sontag, and Jean-Paul Sartre to the early articles by Barthes himself on the visual.[6] In particular, Barthes's insistence on the photograph's 'intractable reality' (the last words of the book), his half-enthusiastic half-trembling immersion in the image, mark not so much a new beginning as the literary climax of a 'naive' or native experience of photographs. I shall thus examine how so many writers, at different times, echoed similar experiences of bewilderment over photography's uncanny realism without, for the most part, communicating it to the world at large, the photographic community in particular, or even one another. Concentrating as I do here on a history of ideas, I leave aside, for the most part, the different and larger issue of literary forms and practices. Yet because literary discoveries of photography since 1839 have tended to be remarkably repetitive, especially in rehearsing the foreignness of photography, I will be particularly concerned with their modes of formulation – public or private, discursive or fictional.

Commentators on these literary accounts of photography have usually emphasized their *content*, i.e. sympathy or – more frequently – antipathy for the natural (or mechanical) image, its magic (or illusion), its democratizing effect on art and visual culture (or its vulgarity and commercialism) and its historical significance as revolution, progress, or new and nefarious religion. Disparaging statements by such figures as Ruskin, Baudelaire, Kierkegaard or Henry James figure prominently in the average anthology of literary quotes on photography – as in the appendix to Susan Sontag's *On Photography* (1977). Collections of such remarks are misleading, however.

Firstly they obscure the silence or near silence of many writers on photography (Balzac, Dickens, Tolstoy, to name just a few masters of Realist fiction).[7] Secondly the factual or ideological content of the statements themselves is often weak, banal or at any rate less historically interesting than the literary discourse of discovery in itself, and its recurring concern with photography's novelty, place in history, or otherness. Thus, more important to me than the contents of such discourse are its *modes of enunciation and circulation*. Many texts now routinely anthologized were considered private, minor, or marginal by their authors, and some of them were only published posthumously. Acknowledging this fact allows one to better understand the history of ideas about photography, its fragmentary and repetitive character, as well as many oft cited cases of 'ambivalence'.

In an unsigned magazine article of 1840, Edgar Allan Poe exclaimed that the daguerreotype 'must undoubtedly be regarded as the most

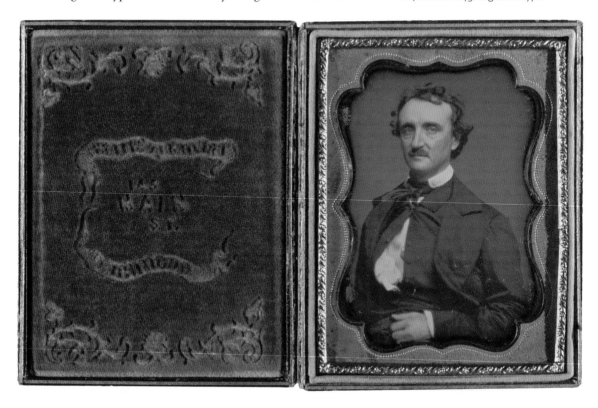

39 William Pratt, *Edgar Allan Poe*, September 1849; daguerreotype.

important, and perhaps the most extraordinary triumph of modern science'. For Poe, the daguerreotype was capable of 'the most miraculous beauty', and '*infinitely* more accurate in its representation than any painting by human hands'. Such an accumulation of superlatives was banal in early accounts. What was not banal was that a writer of some prominence was here unreservedly endorsing an invention that fellow writers regarded with suspicion – even in the US, considered by historians to have been the most photophile territory. Even more surprising is that Poe later authored two other, shorter and clearly technical pieces on improvements on the *daguerréotype*[8] – as he insisted on spelling the word against American usage. All three of these notices were unsigned, however, and no one thought to attribute them to Poe until the mid-twentieth century. Moreover, considering Poe's personal, journalistic and editorial interest in the daguerreotype,[9] it is noteworthy that he almost never made an explicit

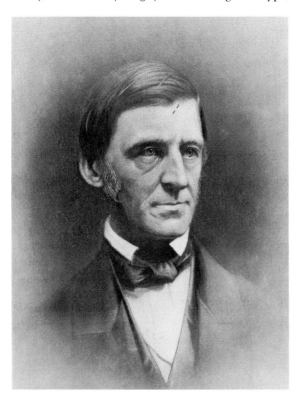

40 Unidentified artist, *Ralph W. Emerson*, c. 1884, mezzotint from photograph.

reference to things photographic in his *literary production* – especially his fiction, where mention of the daguerreotype is reduced to one footnote to 'The Thousand-and-Second Tale of Scheherazade' (1845). This avoidance is striking when one reflects that much of Poe's later fiction is concerned with the issues of authority and (self-) certification, and with narrative procedures mimicking the self-production of tales, signs, voices, or vestiges. His first article touched upon this concern when it imputed the daguerreotype's 'infinite' superiority of representation to the fact that 'the source of vision has been, in this case, the designer'. American popular fiction of the 1840s and 1850s – the kind of fiction that Poe sought to emulate and satirize at the same time – was quick to resort to tricks of photographic revelation. Yet the author of 'A Message in a Bottle' shrank from the subject.[10]

No less instructive is the behaviour of Poe's contemporary and literary enemy, Ralph Waldo Emerson, who manifested a similar ambivalence – or, more precisely, a marked reluctance to *publish* openly his private thoughts

on the discovery. Starting in the fall of 1841, Emerson's journals testify to his mounting interest in the daguerreotype, predictable from his earlier essays.[11] In the journals, a number of entries record Emerson's discovery of the daguerreotype and his eloquent enunciation of the new image's foreignness – in relation to art – and proximity to democratic culture:

> The daguerrotype is the true Republican style of painting. The artist stands aside and lets you paint yourself. If you make an ill head, not he but yourself are responsible . . . A Daguerreotype Institute is worth a National Fast.

At exactly the same time, the sage's experience as a sitter is described as disappointing if not devastating:

> Were you ever daguerreotyped . . . And did you look with all vigor at the lens of the camera . . . [to find that] unhappily the total expression had escaped from the face and you held the portrait of a mask instead of a man.[12]

Emerson, like other writers, oscillated between private frustration – even disgust – with his own image and elation at the image of others (especially of his friend and mentor Thomas Carlyle), and more generally at the social effects of the invention; his wonder at the transfiguring power of the portrait (by which familiar appearances were pleasantly 'unrealized') turned to fright when facing an image of himself that seemed not only degrading but alienating and downright deadly.

Conversely, and singularly, Nathaniel Hawthorne, privately enthusiastic about the daguerreotype, chose to develop a rather satirical view of photography's supposed powers of revelation in a romance (*The House of the Seven Gables*, 1851) whose protagonist, a daguerreotypist, unmasked – with the avowed help of his plates – the injustice of a local potentate only to establish himself, after the latter's mysterious death, in a similar position of power in the end.[13] Unlike his friend Hawthorne, Emerson did not care to publish his thoughts, especially his reservations, on the new image. Save for one or two brief allusions to Daguerre and the daguerreotype in

his lectures and essays, he never incorporated these thoughts into his public writing; once when he did, in a passage of the essay on 'Beauty', he rephrased the language of his journal so as to eliminate the reference to the daguerreotype.[14] Photography was an important stimulus for thought – a kind of criterion – and even a powerful analogy for the process of writing, as suggested by both Emerson's and Thoreau's journals; some-how, however, it could not be brought into public discourse or writing. For both reasons it functioned, for Emerson as for other writers, as a limit.[15]

Many examples of guarded behaviour – of writers keeping their photographic enthusiasms, or phobias, to the realm of the private or the anonymous (diaries, notebooks, letters, minor or unsigned pieces) – could be brought up in the nineteenth century. Elizabeth Barrett Browning – otherwise very suspicious, like the rest of her circle, of the mechanical and commercial fashions of her times – wrote in a (now famous) letter of 1843 of her wonder at 'the fact of the very shadow of the person lying there fixed for ever!' Yet the poet did not vent the enthusiasm her brothers deemed 'monstrous'. Even more striking, on account of the critical echo it has received, is the story of John Ruskin's 'ambivalence' towards photog-raphy.[16] Not enough attention has been given to the fact that Ruskin's early and enthusiastic observations on the daguerreotype – 'the most marvellous invention of the century', he wrote in 1846 – are culled from either letters or late reminiscences of his youth, whereas his later, famous pronouncements against landscape photographs as 'merely spoiled nature', worth 'a great deal less than zero' for 'art purposes', were expressed in his more mature books or in the course of his highly publicized lectures at Oxford. The older critic, to be sure, had grown disillusioned with a tech-nology that had belied its promise of rejuvenation and become an auxiliary of modern vulgarity. Still, hardly one positive remark by Ruskin on photography – save for his oft-repeated statement of photography's usefulness as an aid to drawing – was published during his lifetime.

As shown by these examples, the recurring relegation of photog-raphy into the private realm had to do not only with literary decorum but also with literary narcissism and, above all, literary ethos. That is, the fear of meddling publicly with a 'low' topic was compounded by the discovery of one's own photographic image and the threat that such an

image might 'make an ill head'; and it also echoed the critique of alienation by the machine and the market. Like the general public, many nineteenth-century writers were dissatisfied with their own photographic image and frequently regarded it as a small death; for them this disturbing experience was all the more momentous that, as we shall see in chapter Five, literature and the persona of the writer were becoming, in the same period, conspicuous social institutions and commodity values. Other notable examples show that a successful experience with portraiture did not necessarily warrant a positive judgment on the medium.

One case in point is Charles Baudelaire, whose complex relationship to photography, though often contrasted to Poe's, manifests a similar discrepancy between private uses and reflections on the one hand and public discourse on the other. Baudelaire's opinion on the subject is generally sought in his oft-quoted 1859 diatribe against 'the modern public and photography', a section of his long review of that year's Salon.[17] Described as a 'new industry' threatening to 'ruin whatever divine remained of the French spirit' and the cult of an 'abject society' obsessed with 'its trivial image', photography is indicted as the absolute antagonist of poetry and the imagination, and its beneficial role strictly limited to the menial (and feminine) status of 'maid of the sciences and arts'. This sally needs to be properly contextualized. First, it was motivated by the inclusion for the first time – in a separate but ample section – of photography in the Salon, and Baudelaire's governing argument in his review is an all-out attack on naturalism or the popular ideal of 'exactitude' in modern art – not just in photography. Since 1850 the daguerreotype and photography had been associated by conservative critics with the rise of the new literary school alternatively called 'realism' or 'naturalism'. Writers of this obedience – such as Flaubert and especially Théophile Gautier – were called 'photographic', with a distinct nuance of abuse, by self-styled defenders of the 'ideal'.[18] In this sense Baudelaire was merely epitomizing a debate that gained more acuity in 1857 with the critic Champfleury's manifesto on Realism, which included a parable pitting ten daguerreotypists and ten painters in an open field to conclude that the ten mechanical images turned out identical, whereas among the ten paintings 'not one was like another'.[19]

41 Félix Nadar, *Charles Baudelaire*, between 1854 and 1860, albumen print.

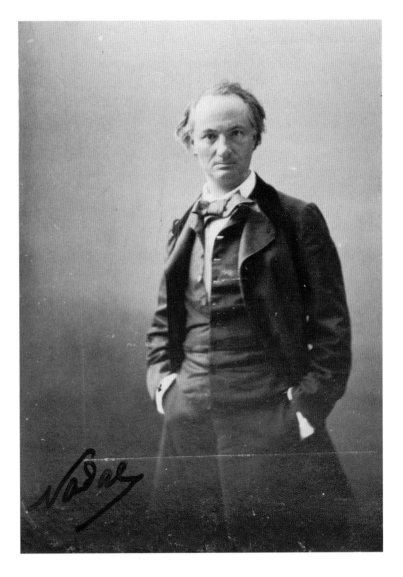

Unlike Champfleury, Baudelaire encompassed photography in a *general* critique of vulgarity and modern taste – fed by the hatred of bourgeois portraiture – which would extend, in his last years, to the manifold manifestations of 'industry', 'commerce', and 'Americanization'. At the same time, it must be stressed that Baudelaire befriended, among

the Paris *bohême*, several of the period's great photographers, two of whom – Nadar and Etienne Carjat – produced, with the active collaboration of the poet, the spectacular portraits of him that have since then attained iconic status. Baudelaire's interest in photographic matters is also attested by his efforts to procure the best possible portraits of his ageing mother (for which purpose he had her travel to Paris). Finally, as has been shown recently, the poet chose to code his *fear* of photography as an auxiliary of modern vulgarity and an omen of death in a highly cryptic sonnet, 'Le Rêve d'un Curieux' ('A Curious Man's Dream', included in *Les Fleurs du Mal* in 1860). Dedicated to 'F. N.' (Félix Nadar), the poem compared the feelings of a sitter in front of a camera to the anticipation and then the disappointing experience of death.[20] Here the photographer served, for his close friend, both as a figure of the enemy in the war between poetry and photography and as a consoling witness, a privileged intercessor in a conflict between the estranged Romantic poet and a threatening crowd.

Meanwhile, from a more historical standpoint, what 'The modern public and photography' registered was the popularization of photography, in the late 1850s, through the collodion process, the *carte-de-visite* format, and the stereograph. In one passage of his essay, Baudelaire linked the taste for allegorical compositions à la Oscar Rejlander and the 'avidity' of 'thousands of eyes' peeping into 'the holes of the stereoscope', citing them as two examples of a 'love of obscenity' which he half-seriously attributed to the influence of 'some democratic writer'. Curiously it has not been noted that in this preoccupation with the public's taste and the social spread of photography, Baudelaire's essay was strongly resonant with two other, almost exactly contemporary texts, written by two authors who might have fallen under the 'democratic' label. These were the long essay published (unsigned, but referenced in the volume's index) by Lady Eastlake in 1857 in the *Quarterly Review* and the first of Oliver W. Holmes's three essays on stereography and photography, published in *The Atlantic Monthly* in 1859 (the sequels appeared in 1861 and 1863). It is almost irrelevant whether Baudelaire found his cue about the 'democratic writer' in Eastlake (Victor Hugo is a better candidate), though we know that he was an avid reader of the English quarterlies (and of some

American publications as well). What matters is the coincidence of the three essays, which defines the first major moment, since 1839, of photography's emergence into public discourse as a social and political medium, indeed a visual form of democracy. Given this coincidence, the differences between Baudelaire's satire and the two English-language essays are all the more striking, and by no means limited to a matter of 'positive' or 'negative' opinion.

The comparison manifests, first of all, a recurring opposition between a French or continental viewpoint and an Anglo-American one. Whereas the former was mostly confined to the contemplation of images and indifferent to the photographer's perspective, for the latter photography was also (perhaps firstly) a practice. Née Elizabeth Rigby, Lady Eastlake, as a close associate of the Scottish photographic circles and wife of Sir Charles Eastlake, first president of the Royal Photographic Society, had an early and rich acquaintance with the medium. Significantly, her long article – presented as a review of technical publications – starts not with the Romantic's dark vision of an 'obscene crowd' of spectators but with the rather 'democratic' prospect of a brotherhood of 'tens of thousands' of photographers, 'now following a new business, practising a new pleasure, speaking a new language, and bound together by a new sympathy'; 'a kind of republic, where it needs apparently but to be a photographer to be a brother.' Though she will retrace the invention's history, Lady Eastlake declares that her chief object is 'to investigate the connexion of photography with art', a stance that is consistent with Baudelaire's and which leads her to conclusions not so distant from his, when she stresses the differential value of photography, capable of helping to elucidate 'the mystery called Art', 'simply by showing what it is not'. This agenda conforms to the general trend of nineteenth-century commentary on photography, governed by the confrontation of photography and painting (or 'art' in general). More specific to Eastlake's essay is a concern with the social uses of photography as that 'new form of communication between man and man – neither letter, message, nor picture – which now happily fills up the space between them'.[21] This discussion of the photograph as *sign* reaches its climax in the following passage, worth quoting in full, of the 'historic' or singular specificity of the photograph:

In this sense no photographic picture that ever was taken . . . of any thing, or scene, however defective when measured by an artistic scale, is destitute of a special, and what we may call an historic interest. Every form which is traced by light is the impress of one moment, or one hour, or one age in the great passage of time. Though the faces of our children may not be modelled and rounded with that truth and beauty which art attains, yet minor things – the very shoes of the one, the inseparable toy of the other – are given with a strength of identity which art does not even seek.

This 'historic interest', with the example of the child's 'very shoes', is in marked resonance with the arguments of *Camera Lucida* on *punctum* and *that has been*.[22] No less significant is the fact that this discovery is due to a woman of letters – author of travel narratives and novels as well as art critic and translator – who brought, in her 1857 essay, her artistic and literary sensibilities to an exploration, aimed at the general reader, of photography's novelty not (only) as art but as language. In spite of its remarkable closeness to Baudelaire's topic and even his highbrow posture, Eastlake's essay is thus vastly more predictive of future critical developments – as are the three papers by Oliver W. Holmes.

Holmes's unique position as a Boston physician, editor of the *Atlantic Monthly*, and influential critic with a strong technical interest in photography and stereoscopy (he built a hand-held stereoscope) is reflected in these three essays, which combine detailed information on photographic practices with an investigation of their cultural significance, couched in an erudite language that is aimed at the genteel readership of the *Atlantic Monthly*. Quotations, literary references and allusions, as well as mythological readings of photography abound in these essays. The 1859 article opens with a witty connection between Democritus' doctrine that 'all bodies [are] continually throwing off certain images like themselves' and the daguerreotype, which 'has fixed the most fleeting of our illusions, that which the apostle and the philosopher and the poet have alike used as the type of instability and unreality'.[23] Similarly, the 1861 essay, 'Sun Painting and Sun Sculpture', starts with the fable of the flaying of Marsyas by the sun god Apollo, proposed as an emblem for the modern process by which

43 Unidentified photographer, *William H. Shippen, 3½ years old*, albumen print on a carte de visite.

'we are now flaying our friends and submitting to be flayed ourselves'.[24] This dark humour presages the insistent connection that Holmes, writing in the context of the American Civil War and its disclosures of destruction and human corpses, establishes especially in the 1863 paper between photography and the spectacles of ageing, injury, and death.

Meanwhile, the 1861 essay offers 'a stereoscopic trip across the Atlantic', based on the author's browsing through a collection of stere-oviews, and laced with historical and literary references which set off imaginary animations of the pictures. Holmes sees or reads 'infinite volumes of poems . . . in this small library of glass and pasteboard', and describes absorption in this virtual library as an experience of disembodi-ment.[25] In an 'excursion' to Stratford-upon-Avon – already a favourite subject of commercial photographers by 1860 – the stereo-traveller wanders about the Bard's house and stops at a picture of its back, 'a strange picture, [which] sets us dreaming': 'did little Will use to look out at this window with the bull's eye panes?' 'Strolling over' to Ann Hathaway's cottage in Shottery, the erudite voyeur notes that 'life goes on in the cottage just as it used to three hundred years ago': 'a young man is sitting, pensive', a cat reminds the viewer of the one 'which purred round the poet's legs' then. In the midst of this reverie on the collision of past and present Holmes declares:

> at the foot of the steps is a huge basin, and over the rail hangs – a dishcloth, drying. In these homely accidents of the very instant, that cut across our romantic ideals with the sharp edge of reality, lies one of the ineffable charms of the sun-picture. It is a little thing that gives life to a scene or face; portraits are never absolutely alive, because they do not *wink*.[26]

However swollen, Holmes's rhetoric admirably demonstrates a connec-tion between literary culture and *romancing* imagination that directly anticipates Barthes's later commentaries, as does his remarkably sensitive analysis of the peculiarities of photographic portraiture. More striking even is the fact that Holmes – who in the 1863 article gives a detailed account of his technical apprenticeship as an amateur photographer –

44 Unidentified photographer, *Stratford-on-Avon — Shakespeare's House, from the Garden*; one half of a 19th-century stereocard.

exploits literary culture in an explicit attempt to implicate his genteel readers in a fuller understanding of a form of entertainment they know without necessarily acknowledging it. This work of cultural education can usefully be read in dialogue and in contrast with Baudelaire's anti-didactic diatribe, and, obviously, in advance of the later similar efforts of Benjamin, Valéry, Berger, Barthes, and especially Susan Sontag, with her particular concern with the image of war, its scandals and its ambiguities.

At least three subsequent moments can be identified in the history of literary discoveries of photography, which I am only outlining here. The first one is centred around 1900 and the 'graphic revolution', and manifests itself, above all, in the emergence of photography as a topic for fiction. Whereas up until 1880 'serious' fiction had been slow to incorporate photographs and photographers, in the following decades both topics became

The Kodak Story

Of summer days grows in charm as the months go by—it's always interesting—it's personal—it tells of the places, the people and the incidents *from your point of view*—just as you saw them.

And it's an easy story to record, for the Kodak works at the bidding of the merest novice. There is no dark-room for any part of Kodak work, it's all simple. Press the button—do the rest—or leave it to another—just as you please.

The Kodak catalogue tells the details. Free at the dealers or by mail.

Kodaks, $5 to $100
Brownies, $1 to $9

EASTMAN KODAK CO.
Rochester, N.Y., *The Kodak City*

frequent.[27] Examples include several of Thomas Hardy's novels (especially *Jude the Obscure* [1896], where on two occasions Jude's behaviour is driven by the chance finding of a photographic portrait, which in the first case is burned, as in Hardy's poem 'The Photograph'), [28] as well as Fedor Dostoyevsky's *The Idiot*, Leo Tolstoy's *Anna Karenina*, and Marcel Proust's *Remembrance of Things Past*, all of which contain key scenes involving the discovery of, the search for, or the meditation on photographs – usually portraits. Popular novels such as Jules Verne's *The Kip Brothers* (1902) resorted to investigations involving photographs, in this case the enlarged detail of the image of a murdered man's retina, delivering a verdict on the culprit.[29] During the same period, numerous short stories were built with either an opening scene or climax involving a photographic revelation. In a sense, such topics signalled a new banality of photography, perhaps even a new distance from the old faith in 'the work of the sun': if photographs became fictional motifs, their truth value could more easily be questioned. At the same time, however, the place of photography in fiction also mirrored its greater presence, or influence, in society, and for some (such as Hardy) it seemed to point to an *excess* of photographic truth, rather than a decline. As Graham Smith has shown, it was this excess that E. M. Forster had in mind when he characterized Sinclair Lewis's style as a 'snapshot method'.[30]

Furthermore, whereas earlier literary responses predominantly addressed photography as a purveyor of images, after 1880 and the 'Kodak revolution' more writers learned to envision photography as a practice, and some, from Emile Zola to Virginia Woolf, actually practised it themselves. Thus not only the encounter with photographs but also the handling and even the making of them became, in Western Europe and also Russia, common enough experiences to make them part of the ordinary literary landscape – in much the same way as they became part of the ordinary philosophical landscape. In Tchekhov's play *Three Sisters*, Fedotik is continually taking pictures of his relatives, while several characters in Proust's *Remembrance of Things Past* declare an active interest in photography; in James Joyce's *Ulysses*, a novel permeated with photographs and meditations on them, Molly Bloom takes up photography as a career.[31] Yet the increasing banality of photography did not cancel earlier ambivalences or the deep-seated sentiment of the image's foreignness to literature.

The period's 'record of thinking' on photography (now in published fiction rather than in private diaries or journalistic essays), especially in France, is dominated by new expressions of its magic powers, coupled in many cases with indictments of its treacherous, dangerous, even murderous tendencies. Two otherwise widely different French novels, *Tomorrow's Eve* (1886) by the aristocratic Symbolist Villiers de l'Isle Adam and *The Carpathian Castle* (1892) by popular neo-Fantastic Jules Verne, similarly stage experiments of photographically based Frankensteinian clones designed by evil and foreign geniuses. (Villiers's engineer is aptly named Edison, and his creature cannibalizes a young woman.) A similar theme was used much later by Adolfo Bioy Casares in *The Invention of Morel* (1940), and countless replicas can be found in sci-fi novels (for instance Philip K. Dick's 1969 *Ubik*).

In *Remembrance of Things Past*, photography's power is also exploited, in a minor mode, in several rituals of discovery and desecration, such as the episodes of Albertine's kiss and the profanation of Vinteuil's portrait by his daughter, while one important thread is the quest for a true photograph – of oneself, of a loved one – in the midst of a deluge of mediocre or vulgar images. While the Kodak and its practitioners symbolize the vulgarities of modern visuality, late in the novel the unexpected, devastating meeting with the narrator's grandmother, now reduced to a shrivelled old thing, is formulated as the taking of a photograph.[32] The same vulgarity and the same power of social engineering were attributed to photography by Henry James in 'The Real Thing' (1892). In this highly satirical short story an illustrator is confronted with a couple of models, Mr and Mrs Monarch, who are convinced that they are the embodiment of style ('the real thing') yet prove utterly worthless at posing. Because, as they claim, '[they] have been photographed – immensely', they have become mere images, devoid of any substance.[33] In this story, as in Proust's larger world of images, what will later be called the simulacrum is pointedly designated as the enemy of literature, but also as one of the topics in literature's ongoing critique of modernity.

A second moment in the continuing literary discovery of photography took place in the 1930s. In a 1939 speech on the centennial of photography, Paul Valéry pondered the effects of 'the mere notion of photography' on literature and history, identifying a 'new kind of reagent whose effects have

46 Léon Benett, 'Franz de Télek!', chromolithograph illustration for Jules Verne's *Le Château des Carpathes* (Paris, 1892), showing Count Fanz de Télek at the castle of Baron Rodolphe de Görtz confronted by the image of the prima donna La Stilla.

« FRANZ DE TÉLEK!.. » S'ÉCRIE RODOLPHE DE GORTZ. (Page 190.)

certainly not as yet been sufficiently explored'.[34] Following, albeit rather quietly, in the critical footsteps of Baudelaire and Proust, Valéry was echoing in this rather obscure piece recent developments such as Surrealist experiments as much as he was (unknowingly) rehearsing Poe's old statement about photography's unmeasured novelty. Christopher Phillips has observed that the artistic generation who came of age in the 1920s and 1930s, inspired by the groundbreaking visual and multi-media experiments of European avant-gardes, repeatedly described photography 'as having only recently been truly discovered'.[35] This urge to re-evaluate the invention of photography was stimulated by the emergence of illustrated news media and, for many, by political urgency of the time and the relevance of the

47 Man Ray (Emmanuel Radnitzky), Surrealists' Group in a *rêve éveillé* session, *c.* 1924; black and white photograph.

48 Gisèle Freund, *Walter Benjamin, Paris*, 1938, colour print.

camera in social and political struggles.[36] In an age of alienation by the machine, it also incorporated mounting defiance of modernity, as in the French writer's Georges Duhamel's *Scènes de la Vie Future* (1930), which contained a furious attack on (American) cinema.

When Valéry prudently enunciated a parallel between the advent of photography and that of the 'descriptive genre', that is, literary realism, he was rehearsing an opinion that had become current in the 1930s, along with the concurring parallel between photography and painting's 'flight' into abstraction; both ideas were tainted with an uneasiness that owed both to the period's political threats and the larger fear of a destabilization of culture by the machine. Walter Benjamin's interest in photography and reproducibility, or Gisèle Freund's remarkable 1936 dissertation on the 'sociology and aesthetics' of nineteenth-century French photography,[37] cannot be properly understood without paying due attention to this context as well as to the role of literature (Baudelaire especially) as beacon of a critique of modernity. By 1940, literary culture had become the privileged source for investigating photography's (and cinema's) now largely acknowledged macro-historical impact; after the war this fact would be a given for new historians of culture and the 'civilization of images', from André Malraux and André Bazin to Siegfried Kracauer, William Ivins, and Daniel J. Boorstin.

The third moment was the post-1960 explosion of literary, photographic, photo-literary, and conceptual experiments, which came to make literature (and the book) photography's natural partner. The 1950s saw an amplification of the earlier pattern of fictional investigations involving photographs or photograph-taking, especially serving as plot triggers, and often leading to or revealing murders, as in Agatha Christie's novel *Mrs McGinty's Dead* (1952) and short stories such as Eugène Ionesco's 'The Colonel's Photograph' (1955), Italo Calvino's 'The Adventures of a Photographer' (1955), and most famously, Julio Cortázar's 'Blow Up' (1959) – adapted into a film in 1966 by Michelangelo Antonioni. As Jane Rabb has

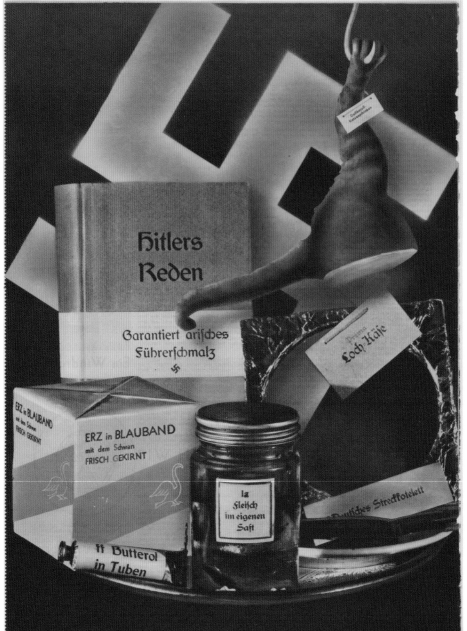

shown, photography now became a regular theme of short stories (a pattern that started earlier in the twentieth century, from Anton Tchekhov and Rudyard Kipling to Vladimir Nabokov, Thomas Mann, and Bing Xin, and which would flourish, in the 1970s and '80s, in the USA).[38] Long stories or novellas rehearsed, particularly in the mode of ekphrasis, the older mode of discovery, though they tended to emphasize the photograph's incompleteness or inaccessibility rather than its inexhaustibility. In *Noé* (1961) Jean Giono recounted an unrealized fictional project where the full narrative of a country wedding developed out of a series of photographs.[39] In *Three Farmers on Their Way to a Dance* (1985), Richard Powers brilliantly executed this idea in a book-long narrative explication of August Sander's photograph of the same title.

By 1980, although Roland Barthes identified photography with the New, its novelty was declining in popular culture and becoming a didactic theme, while novels that perpetuated the theme of discoveries in photographs were often set in a nostalgic tone or a climate of amnesia, as with Patrick Modiano or, later, W. G. Sebald.[40] As suggested by his concluding remarks in *Camera Lucida* on the futility of domesticating photography's 'madness' into art, Barthes was aware that its description as a 'new art' was losing ground, and that those concerned to keep the old amazement at its realism alive (i.e. the amazement at its ability to certify reality)[41] would henceforth need to inculcate this experience in postmodern audiences raised in scepticism. In this sense, *Camera Lucida* recapitulated not only a century and a half's literary tradition of discovering photography but also its own, shorter, generational timeframe, where in the wake of Structuralism the photograph had become a prime object for semiotic and anthropological analyses of modern media and messages. In some cases, the 'new' media analysis explicitly clashed with literary culture, as when Marshall McLuhan bashed Daniel J. Boorstin's critique of 'pseudo-events' as 'literary'.[42] But European semioticians from Louis Hjelmslev and Algésiras Greimas to Umberto Eco and Barthes, and McLuhan himself, always envisioned the analysis of iconic and other messages against a literary background. And prior to *Camera Lucida*, the most influential essays on photography in the 1970s – besides those of visual critics such as John Szarkowski – were often the work of literary

49 John Heartfield, *Neueste Muster der Nazi-Lebensmittelindustrie 1936* ('Latest samples of the Nazi food industry 1936'), rotogravure print of rephotographed montage, published in *Arbeiter-Illustrierte Zeitung*, 9 January 1936.

51 Cover of Susan Sontag
On Photography (New York, 1977).

critics, first and foremost Susan Sontag. The latter's *On Photography*, published in 1977, dwelt on a nostalgic confrontation of the Whitmanian vision of ordinary heroism to the disenchanted world of contemporary (American) photography, instanced by Diane Arbus's portraits of urban freaks. Since World War II, according to Sontag, 'the Whitmanesque mandate to record in its entirety the extravagant candors of actual American experience has gone sour'.[43] Barthes only discreetly acknowledged the work of Sontag – his correspondent for some time – by noting her emphasis on the pornography of death and suffering; but it may be suggested that an analogously tacit relationship linked Barthes to Sontag and the older and less obvious duo of Charles Baudelaire and Lady Eastlake. Their common posterity – along with the diffusion of Walter Benjamin's work – would be strongly felt in the work of later critical voices on photography, from W.J.T. Mitchell to Bernd Stiegler, from Régis Durand to Rosalind Krauss.

In the same period, the postmodernist critique of an image-bound culture of 'simulations', in Jean Baudrillard's phrase, would become a leitmotiv of much contemporary fiction, especially in the US, from Walker Percy to Paul Auster and Don DeLillo, in whose novels the scrutiny of photographic or video images leads one to a form of blindness – the discovery not of 'infinite detail' but of an abyssal void. Yet the paradox of Barthes's posterity was that his celebration of photographic realism, unconcerned as it was with the photographic art or the photographic author, coincided not only with a new attraction of literature for the medium but with the advent of the photographer as a fully fledged literary voice.

50 Ercole Brini, Poster for Michelangelo Antonioni's *Blow-Up* (1966).

four

The Literature of Photography

Does it make any difference what subject matter is used to express a
feeling toward life!
Edward Weston, *Daybooks*, May 20, 1927[1]

The nineteenth-century photographer was not, in general, much of a
writer, let alone a writer of literature; photography was usually not con-
sidered to have much to do with imagination, let alone the imagination
of oneself. The inaugural moment in 1839, when François Arago spoke
to the academies in lieu of Daguerre, was the beginning of a long period
during which to be a photographer usually meant not to have a voice –
for various reasons. Hippolyte Bayard, the unlucky rival inventor who
tried in vain to interest the academies in his paper process in 1839, was
quite literally muffled by Arago. He chose to comment visually and silently
on this eviction in his now famous self-portait as a drowned man, one of
several explicitly fictional images which, from today's vantage point, recall
later practices of derisive or distorted self-representation. Self-portraiture,
even unacknowledged and merely experimental, was probably a more
common procedure for self-presentation than organized written discourse
among the first photographic generations; more generally the insertion of
reflections, shadows or inscriptions of the photographer in the photo-
graph was a discreet procedure for reminding viewers that the sun
picture was not solely the work of the sun.

Still, few nineteenth-century photographers published anything
beyond a few technical articles, and many of those today considered
among the century's greats have left hardly anything in the way of written

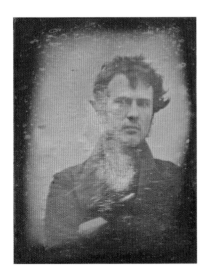

52 Robert Cornelius, *Self-portrait*, September or October 1839, quarter-plate daguerreotype.

53 Hippolyte Bayard, *Self-portrait as a Drowned Man*, 1840, direct positive print.

traces – even accounts or letters. It is true, conversely, that many others scrupulously kept diaries and archives (a few published at the time, most emerging posthumously). It is also true that in most countries some advanced amateurs and, more commonly, the leaders of the profession published manuals and treatises, some of them quite extensive and ambitious. 'Literary' amateur photographers such as Edward Bradley (writing on 'Photographic Pleasures' in 1855 under the humorous pseudonym Cuthbert Bede), Julia Margaret Cameron, Lewis Carroll ('Photography Extraordinary', 1855), and later Arthur Conan Doyle, H. G. Wells and George Bernard Shaw, constitute a peculiar English tradition, marked by a consistent conviction of the poetic, fictional, and humoristic powers of photography. The American professional Marcus Root, who turned to

writing after a severe accident,[2] titled his 1864 treatise *The Camera and the Pencil* to signify that writing and drawing could be combined with the portrait photographer's many talents in an effort to elevate photography to fine art status. In such books, often as preoccupied with legitimization as they were with the teaching and 'improvement' of the trade, literary quotes abounded, as if to lift the nascent art above its mechanical roots.

By contrast, the literary and archival silence surrounding such 'early masters' as Timothy H. O'Sullivan or Eugène Atget – not to mention lesser figures – is remarkable, and has not been given enough consideration. Indeed, this silence is inseparable from the intensely speculative character of much of the criticism devoted, from the 1930s on, to these two 'anonymous' ancestors of photographic modernism.[3] At any rate, the issue of how photographers have related to writing, literature, and expression is, in my view, closely linked to the issue of their public, social status, and by the same token to the various ways photographers have chosen to represent themselves. Thus in this chapter I will be particularly concerned with the emergence, in the twentieth century, of a more ambitious discourse and writing effort by 'serious' photographers, which has contributed powerfully to a new understanding of photography as an expressive, indeed often autobiographical, medium. In focusing on the issue of self-representation and expression, I will dwell on the emerging definition of the photographer as writer and storyteller, an often overlooked trend which points to the rise of photography as an art of *eloquence*. Nonetheless, paying attention to the development of fictional and performing procedures in the later twentieth century, I will not limit the issue of self-representation to its rhetorical manifestations, and consider *theatricality* as another emerging literary aspect of photography. By 2000 the old silence of nineteenth-century photographers had, for many, been vindicated as a newly relevant context for photographic performances.

Around 1900 a series of testimonials and some larger-scale autobiographical statements appeared, written by veterans of the first photographic century. This trend began in the 1870s, and in the following three decades a number of autobiographies, histories, and shorter reminiscences were produced by photographic veterans such as, in England, Julia Margaret

54 Félix Nadar, *Le Mime Debureau: Pierrot photographe*, 1854–55, albumen print.

Cameron (her unfinished narrative from 1874–9 published in 1890 as *Annals of my Glass House*) and John Werge; in the USA Albert S. Southworth, J. F. Ryder, Mathew Brady (in the 'Townsend interview' of 1891); and in France, most famously, Nadar (in *Quand j'étais photographe/My Life as a Photographer*, 1900, a full-scale literary autobiography). Gaspard-Félix Tournachon had formerly produced – with his brother Adrien – a beautiful allegory of photography in the 'Pierrot' series, impersonating photography as a mime, theatrical and versatile like himself, yet pointing a seemingly accusing finger at the camera as if to denounce photography's threatening new powers.[4] Before 1900 Nadar had already published several autobiographical accounts concerning especially his experiments in balloon travel and aerial photography. As the French title of his definitive autobiography of 1900 indicates, Nadar by this stage situated 'photography' in the past of his long life and of (French) cultural history; Léon Daudet's preface called him 'a witness of the past fifty years'. The book was actually a collection of short pieces with diverse topics and styles, mostly autobiographical and often anecdotal though some were grave and even macabre (especially the famous narrative of photographing in the Catacombs, and 'Homicidal Photography', a fictionalizing account of a landmark murder case in the 1860s). Other articles, however, such as 'The primitives of photography', attempted to provide a history of the medium, and the volume opened with a now famous reminiscence of 'Balzac and the daguerreotype', where Nadar revealed the writer's apprehension of the invention and his 'theory' of spectral emanations; as another piece, on the cultural atmosphere of the 1830s, confirmed, the emphasis was clearly on the advent of modernity – the transformations of (French) society witnessed and even wrought by photography.

This burst of photographic confessions around 1900 had to do not only with the mere autobiographical impulse of former luminaries but with the awareness for most of them that the end of their careers coincided with a great mutation in their craft. Their new urge to speak and write publicly was motivated by a new awareness of photography as having 'made history' (and, for Nadar or Brady, having recorded much of their national histories) but also as having 'become history', especially since the rise of small formats, film, and popular photography after 1890.

Recurrent among these veterans' memoirs was the observation (sometimes the lament) that, with the advent of the Kodak and the ensuing decline of the traditional professional and technical mindset, photography had changed and was becoming a toy, at best a form of popular culture. Brady's nostalgic reminiscences of his many acquaintances in the cultural elite of antebellum America, like Cameron's moving impressions of the numerous literary figures who passed before her camera, and Nadar's accounts of his friendships with the French intelligentsia from Balzac to Baudelaire, are gentle reminders of a golden age of the photographic art that pioneers felt was fading in the era of snapshots, illustrated postcards, and movies. Postcards especially, as a popular form of communication, registered the new availability of pictures as writing surfaces, and the rise of an ordinary discourse of travel and memory that in some ways superseded the earlier, more ambitious travel narratives.

55 Unidentified photographer, *The Rapids above the Falls. Greeting from Niagara Falls*; lithochrome postcard c. 1907. Inscribed 'Last night in Buffalo – Finest ever happened, Ed', and postmarked Niagara Falls, 7 September 1907.

56 Unidentified photographer, *Forest Lake, Whitefield*, N.H.; *c.* 1906, colour post-card. Inscribed 'Do you remember the Sunday we spent on this island? Bill.', and postmarked Whitefield, 16 August 1906.

The retrospective brand of photographic autobiography would continue throughout the twentieth century, usually associated, as before, with photographers' claims to have documented, been part of, even made 'history', away from explicit aesthetic concerns. A prime example is the dizzying autobiographical and memorial output of the American land-scapist William H. Jackson, who lived to ninety-nine and published several versions of his memoirs along with countless historical articles on the beauties and hardships of 'pioneer photography' before the advent of 'kodakery'. (His most 'official' life story, *Time Exposure*, appeared one year before his death in 1940.) In his obsessive iteration of his experience as a 'pioneer photographer', he hardly ever commented on his images, con-centrating instead on a narrative of (often heroic) picture-making.[5] His nostalgia took on an explicit pastoral turn, which echoed the rising aware-ness, in several countries during the 1930s, that photography had not only recorded the advent of modernity and a new visual culture but crucially helped it. Thus in the 1930s the autobiographical or memorial impulse of Jackson and others was echoed by the first 'social' or 'cultural' histories of photography, which, like Robert Taft's monumental *Photography and the American Scene* (1938), considered photography as heritage or folklore rather than art in the sense pursued by a few collectors and curators at that time.

57 William Henry Jackson, *The Grand Canyon in Arizona, c.* 1900, photochrome print.

The earlier survey by Helmut Bossert and Heinrich Guttmann in Germany,[6] a source for Walter Benjamin's 'Short history of Photography' (1931), was another such text. Arguably, the 'short' format of Benjamin's history was a discreetly sarcastic comment on the ever-expanding scale of the literature of photography in the 1930s, just as the subtitle of Barthes's *Camera Lucida* ('A Note on Photography') hinted at its rapid aggrandizement in the 1970s.

Although the emphasis of the 1970s was on photographic style, still Jackson's heroic model endured, after being illustrated in particular by news and agency photographers or photojournalists, whose working contexts and

social functions often resembled those of nineteenth-century expeditionary operators. Robert Capa (especially in *Slightly Out of Focus*, 1947, a tragicomic account of World War II that became a model for the literature of action photography),[7] Brassaï and Robert Doisneau are some examples in point. By the end of the twentieth century, however, the nostalgic or pastoral tone had become a more tenuous voice in photographic literature; while writing and publishing books had become a mark of photographic achievement, and while much photo-literature had a strong self-representational dimension, it no longer predominantly followed the 'pioneer' pattern – at least until the digital revolution produced a new round of nostalgic outpourings.

Since 1900 another important form of discourse besides the memorial had accompanied the ongoing crusade of the avant-gardes (pictorialist and then modernist and surrealist) in favour of photography as art: the manifesto. To be sure, apologies for art photography had existed earlier, especially in England (where the Royal Photographic Society functioned, very early on, as a pre-pictorialist circle) and even in France; in the US Marcus Root claimed that 'heliography', as he called the medium, was not only among the fine arts but 'high' in their rank, while in Germany Hermann Vogel championed in-depth understanding of photographic technologies as a precondition for successful artistic practice. Nonetheless, the pictorialist movement went further in producing and promoting criticism in the service of photography as art, and rallied writers to this cause. The European pictorialists – before their American counterparts – put unprecedented ardour into the fight, enlisting much of the literary and artistic world and gaining a new social visibility for photography by publishing refined critical discussions in leading intellectual magazines.[8] Foremost on the English and European scene was the Cuban-born Peter Henry Emerson – a distant relative of the philosopher, from whom he inherited an unshakeable faith in self-reliance as the artist's cardinal virtue – whose impassioned manifesto for 'naturalistic photography' combined a detailed understanding of photographic techniques with a distinctly post-Romantic aesthetics, or ethics, praising photography as a 'medium' for expression.

As is well-known, this trend culminated with Alfred Stieglitz and his prolonged, intensive 'battle' – on account of both 'serious' photography as a whole and his own endeavours. Though the leader of the Photo

58 Gertrud Käsebier, *Alfred Stieglitz*, 1902, digital copy from dry-plate glass negative.

Secession notably did not write books, he published two of the era's most important periodicals, *Camera Notes* (1897–1903) and *Camera Work* (1903–17), which printed many of the most influential contributions at the time, including those of writers (Stieglitz later claimed to have 'discovered' Gertrude Stein) and critics (notably Sadakichi Hartmann, perhaps the period's most incisive analyst).[9] Even before he embarked on his crusade for photography, Stieglitz had been in the habit – inherited from nineteenth-century technicians – of publishing commentaries on his photographs in the specialized press, and these took on an increasingly aesthetic turn.[10] In his now famous exegesis of his picture *Winter – Fifth Avenue* (1893), he described his patient vigil, on a cold winter evening on Manhattan's snowy streets, for the moment 'when everything is in balance'. This an example of Stieglitz's aesthetic credo – but also of his remarkable ability to formulate and propagate this credo in writing. It has become banal to say that Stieglitz inaugurated photography as art, and more specifically 'the photographer's eye' as the real creative agency of this art. To this claim it must be added that, from Stieglitz on, the photographer's pen and rhetoric became the accustomed auxiliaries of this creative eye – a remarkable reversal from the time of Talbot and Daguerre, when even for Talbot the pencil of Nature was potentially a substitute, not only for drawing but for writing.

From Stieglitz on, an increasing recognition of the great photographer as an artist endowed with a special visionary talent went hand in hand with the notion that 'great photographs' were symbolic constructs that involved conscious choices and thus called for commentary and narrative. Stieglitz himself, and some of his protégés such as Paul Strand, greatly contributed to this trend, which also enforced the prevalence of the first person singular – of the 'I' – in the new discourse of photography. It is no accident that the various pictorialist and modernist photographic circles relished and popularized the self-portrait as a valid genre in a medium where previous experiments in this line, if quite numerous, had most often been either private or not explicit. It is also no accident that these groups popularized a highbrow manner of captioning (or 'titling') images, often resorting to metaphor and literary allusion – one classic example being Stieglitz's own cloud series, *Equivalents* – which

greatly contributed to a qualification of photography as a Symbolist art. This new semantic and rhetorical density of photography would be enshrined in a collective tribute entitled *America and Alfred Stieglitz: A Collective Portrait* (1934). The book gathered an impressive array of modernist writers and critics (among them Lewis Mumford, William Carlos Williams, Waldo Frank and Paul Rosenfeld) in an effort to assess Stieglitz's photography, and incidentally to enlist its service for cultural nationalism; even before this cult object appeared, Sherwood Anderson, Theodore Dreiser and Hart Crane had published their (usually eulogious) observations on Stieglitz's photographs.[11]

A few years later, Beaumont Newhall's retrospective exhibition of photography's first hundred years for New York's new Museum of Modern Art would capitalize on Stieglitz's 'invention of photographic meaning', in Alan Sekula's phrase, constructing an ambitious narrative of the history of photography as a *medium*, which incorporated a good deal of literary sources.[12] Walker Evans's 1938 *American Photographs* was accompanied by an eloquent discussion by Lincoln Kirstein, and prompted William Carlos Williams's *Sermon with a Camera*. In 1926, for Virginia

59 Andor Kertész, *Self-portrait*, 1927, gelatin silver print.

Woolf and Roger Fry to publish a volume of Julia Margaret Cameron's photographs had been a bold move. But later in the century, the prefacing or commentary of photographers' books by writers became common practice, examples including, in the post-war period, James Agee on Helen Levitt's *A Way of Seeing* (1946); Jean-Paul Sartre on Henri Cartier-Bresson's *D'une Chine à l'autre* (1954); Langston Hughes on Roy DeCarava (1956); Paul Éluard and Jean Cocteau on Lucien Clergue (1957); Jack Kerouac on Robert Frank's *The Americans* (1958); Lawrence Durrell on Bill Brandt (1961); and Yukio Mishima on Eikoh Hosoe (1963). Undoubtedly a detailed study of this genre would shed light on the evolving literary recognition of photography in the second half of the twentieth century.

One representative champion of the rhetoric of expression through photography, and its discontents,

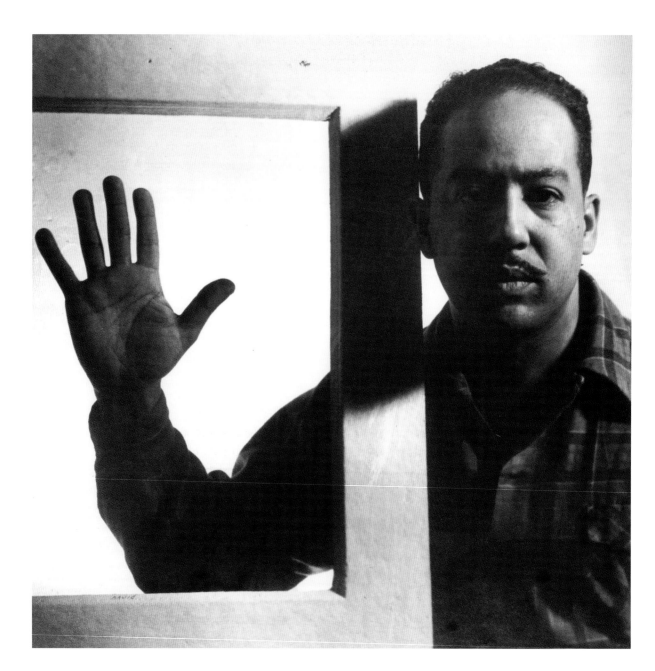

60 Gordon Parks, *Portrait of Langston Hughes*, 1941, gelatin silver print.

was, from the 1920s to the '50s, the Californian landscapist Edward Weston, whose pictures of sand dunes, peppers, or toilet bowls are the classic examples of a Symbolist brand of photography. His *Daybooks*, a prolific diary covering his activities between 1923 and 1934 and published from 1928 on, painstakingly recounted, through narrative and description (though usually not, as Ansel Adams noted, by 'explaining' his pictures), the photographer's quest for representation or 'revelation' of 'the thing itself'. Beaumont Newhall wrote that the intensity of Weston's diaries made them comparable only to Delacroix's journals.[13] Though contemporary with Jackson's memorializing enterprise, Weston's autobiographical prolixity sharply contrasted with his predecessor's by foregrounding photography as a means of expression and obsessively spelling out its limitations in achieving the adequate image, often on account of the subject's spiritual import; even his rebuttals of adverse criticism partook of an urge to justify his 'vision' in existential terms. In the 1950s, this rhetoric of expression was carried to a new degree by Minor White and his magazine *Aperture*, which actively linked the promotion of art photography with a highly spiritual – bordering on metaphysical – approach to the phenomenal world.

The existence of this American tradition of writer-photographers, as much as the more conspicuous heritage of photographic books, is an important component in the making of John Szarkowski's influential essays of the 1960s and '70s, when the former photographer, then curator at New York's MOMA, considerably shaped the photographic scene in the US and abroad through a series of exhibitions and catalogues. *The Photographer's Eye* (1966) must be understood in this lineage, and not merely as the outcome of a long modernist struggle, going back to Stieglitz and Newhall, to win autonomy for the medium on the basis of its formal characteristics – although it certainly belongs in that tradition.[14] Just as Newhall had also incorporated a photographer's practical sensibilities and a certain sense of cultural minority in his art-historical construction of the medium, John Szarkowski sought to establish the validity of the photographer's point of view in the museum, especially at the MOMA, where Edward Steichen had previously privileged a more social approach. *The Photographer's Eye* was the mature achievement of an urge, shared by Stieglitz, Weston and White, to spell out the *rhetorical* import of

photographs, the *language* of photography – the 'I' bespoken by the 'eye' – mirroring the world's phenomena. With Szarkowski this urge to *speak* photography was balanced by an obvious respect for its more silent tradition, more or less identified with 'vernacular' and then 'documentary' artists, from O'Sullivan and Atget to Walker Evans, Robert Frank and Gary Winogrand or Diane Arbus, the last two in the *New Documents* show (1967). But the Szarkowskian credo clearly aimed at reconciling photography's power of revealing the phenomenal world and the photographer's will to expression; one of his last shows at MOMA, *Mirrors and Windows* (1978), would focus on this very dialectics and thereby accentuate, in the public eye, the view of photography as 'holding up the mirror', not to Nature, but to the photographer's self.

In Europe in the 1970s, the emergence of a specialized critical discourse and of a few publishing and institutional outlets for 'serious' photography was influenced by this American tradition and similarly boosted by the efforts of photographers and photographic groups themselves, who, for instance, led magazines like *Camera*, *Les Cahiers de la Photographie* or the *Rivista di critica e storia della fotografia*. In France in the early 1980s, the nascent institutionalization of photography was manifested by the inauguration of the *Mois de la Photo* and several large-scale institutions or projects, including the creation at the new Orsay Museum, from its outset, of a full-blown department of photographs. The trend was also reflected by the growing interest of the press, TV and publishing worlds in diffusing not only photographs but photographs with commentaries by their authors or by others – as in Agnès Varda's short daily show *Une minute pour une image* (1983) on the TV channel France 3 (with a column of the same title in the daily *Libération*), and the collection *Ecrit sur l'image* co-published by *Libération*. Among the latter's first instalments were the Magnum photo-reporter Raymond Depardon's *Correspondance newyorkaise* (1981, with text by Alain Bergala), and Sophie Calle's *Suite vénitienne* (1983, with text by Jean Baudrillard) and *L'Hôtel* (1984). While Depardon's photographs and short captions, in loose allegiance to a 'street photography' tradition, cultivated a Minimalist style which Alain Bergala rightly glossed as foregrounding the photographer's 'absences', Calle conversely staged her 'suite' (meaning both

61 Front cover of Raymond Depardon / Alain Bergala, *Correspondance newyorkaise* (Paris, 1981).

102

Ecrit sur l'image.
Raymond Depardon Correspondance new-yorkaise. Alain Bergala Les absences du photographe.

relle), Raymond Depardon n'essaie jamais de les oublier ou de les fuir, ni même de les citer (ce qui serait encore une façon de les projeter hors de lui), il accepte avec une grande sérénité qu'elles viennent imprégner, pour reprendre la *peredingnes* de Pavese, sa propre vision photographique de New York. Ce qui est encore le plus sûr moyen (mais peu de photographes ont la sagesse de l'accepter) de « réapprendre à regarder » comme il dit en avoir besoin (le 22 juillet), et de se retrouver dans ses images. Se retrouver, là où tant d'autres photographes tentent hystériquement de s'afficher avant même d'avoir pris le temps de savoir à quoi ils ressemblent. De ce photographe, qui arpente les rues de New York, hanté par une image prise au même endroit vingt ans auparavant par un autre photographe et qu'il promène partout dans sa tête, on pourrait dire aussi qu'il a des absences (qu'il a affaire au grand Absent), qu'il manque à être tout à fait présent à cette rue, à cet instant, mais dans ce manquement même il a quelque chance d'être présent à cette pulsion de photographier qui passe aussi par l'identification aux photographes qu'il admire, laquelle est constitutive, tout autant que les sollicitations du réel immédiat, de son désir et de ses difficultés de photographe.

Ce n'est sans doute pas un hasard si c'est précisément à New York que Depardon a accepté de se lancer dans cette expérience d'une correspondance photographique. J'y vois une façon de se choisir une famille photographique, de s'inscrire dans une filiation, celle des photographes américains des années 50, et de se démarquer de sa famille « naturelle » : l'école française de la photo de reportage. Je ne doute pas une seconde, pour ma part, que ce soit le bon choix pour un photographe qui n'entend pas se limiter aux effets de maîtrise et au confort moral de l'instant décisif.

Ce qui s'est passé au cours de ces fameuses années 50, dans la photographie américaine, avec l'intervention fulgurante d'un jeune

24 juillet 1981, New York. Toilettes « dames » du magazine américain Géo, 450 Park Avenue. J'ai envie de faire des photos à la « chambre » - J'ai envie de faire ma famille dans la Dombes. Je pense à la campagne... ça doit être la moisson maintenant ! (Paru le 28 juillet).

60

61

Libération/Editions de l'Etoile.

a narrative or musical sequence and a suite in a hotel) as a narrative and fictional apparatus for self-representation or, rather, self-fictionalization (dubbed 'Please follow me' by Baudrillard).

As is plain from this example, eloquence and the aesthetics of expression, à la Weston or White, were not the only means by which photographers turned photography into literature in the late twentieth century. Among the many modes that the younger medium inherited and appropriated from its once overbearing partner are narrative, fiction and poetry. Narrative works and presentations of works had already been popular in the nineteenth century, when many photographic ensembles, later appreciated for their formal qualities, were designed and published in serial formats and with narrative framing (especially the albums discussed in chapter Two), and when popular forms of photography, such as stereoviews, routinely grouped images by set, theme, or story. Following the model of Bayard and others, this exploitation of photography as narrative was often combined with fictional constructions, especially with a view to allegory and edification, but also in a mode of 'recreation'.[15] As is well-known, photographic allegories were especially popular in the third quarter of the century in England, where Queen Victoria is said to have been fond of Henry P. Robinson's and Oscar Rejlander's illustrative composites and tableaux. As Michel Foucault noted in the 1970s, in the 1860s photography had already opened, at the hand of these recreational artists, 'a great play space' – where the game consisted in giving life-likeness and photographic authenticity to obvious non-entities, and thus playing on the borders between the real and the virtual.[16] This game had more morbid or more exploitative players in the adepts of spirit photography,[17] and reached a poetic and rhetorical climax in Fred Holland Day's series of impersonations of himself as Christ. It also had everyday practitioners in the many photographers for whom 'composing' a photograph meant arranging its elements, sometimes to the extent of creating the scene to be 'recorded'. Later, and quite durably, fashion and advertising photography were, along with propaganda as practiced in the photomontage, the main avenues for photographic fictions.

Still, the bolder and more influential fictionalizing enterprises tend to be grouped after 1970, in a whole array of works and bodies of works,

62 Henry Peach Robinson, *The Painter, a Genre Scene*, 1859, albumen print.

generally characterized as postmodern on account of their sceptical outlook on photography as an image of the world, indeed on representation in general. Often referring to nineteenth-century illustrators, these new pictorialists – performing artists as much as photographers – pushed narrativizing and 'arranging' techniques beyond the limits of any recognizable 'realism'. Thus, a decade or two before the popularization of digital photography the very authenticating power of photography was turned on its head by its new alignment with storytelling, playacting or masquerade. As Miles Orvell puts it, by the 1970s 'the practice of fiction photography was a strong, if not dominant, strain in American art photography.'[18] Many photo-performances and

narratives of the post-1970 era involved photographers in (re)presen-
tations, or rather productions, of their own selves, stories and bodies
(Duane Michals and Cindy Sherman being perhaps the prime examples).
As early as 1976 the incisive photo-critic A. D. Coleman identified a
'directorial mode' in contemporary photography, harking back to
various features of Pictorialism.[19]

63 Duane Michals, *Alice's Mirror*, 1974, sequence of seven gelatin silver prints pasted on cardboard.

Later works in this narrative and theatrical line would tend to replace the more traditional self-portrait with new forms, usually involving multiple and/or serial images, constituting varieties of photographic autobiography usually concerned with identities, family narratives, gender roles, ethnic or sexual nonconformity, or disease (subjects addressed by, among others, David Hockney, Hervé Guibert, Nan Goldin, Francesca

Woodman and Carrie Mae Weems). Other specialists of photographic fiction foregrounded the photographer, not as persona, but as stage director, architect, or quasi painter (such as Bernard Faucon), often linking photographic practice with conceptualism, multi-media, or painting (for example Christian Boltanski and Elizabeth Lennard). This formed part of the larger process Harold Rosenberg called the 'de-definition' of art; often, their cultural models were literary as much as pictorial. Composing tableaux with grotesque dolls (as Hans Bellmer had done in the 1930s) or oversized, masked nude actors posing amid religious and pornographic symbols, Joel-Peter Witkin openly reversed the Victorian allegorical discourse of edification by creating wholly fictional, deeply disturbing images; a little later, Jeff Wall also harked back to nineteenth-century concerns, though perhaps not to theatricality, when he staged large-scale compositions implying silent, unedifying, narratives – sometimes explicitly literary, though not 'illustrative' *(After 'Invisible Man' by Ralph Ellison)*. The emphasis therefore shifted from what can be *said* in photography – either by words or by images – to what is *done, happening,* or *produced* in the photographic 'act' or transaction, whether construed as a concreted presence of the photographer or his/her eclipse, voluntary or not. In particular, deliberate *silence* was now claimed as a photographic virtue, the trace of an unspoken or unpublished reserve or preserve of meaning where images drew their source (as in the case of Nan Goldin's 'secret' diaries). Though much of post-1970 creative photography included narrative aspects of one kind or another, a large proportion of such photo-narratives sought to avoid verbal formulation, more generally to replace the nineteenth-century ideals of 'connectedness' and mastery with recordings of the (postmodern) subject's experiences of incompleteness, de-centring, and loss of faith in any master narrative – especially written.[20]

At the beginning of the twenty-first century, avant-garde photography has moved so far out of its nineteenth-century boundaries that the once transgressive model of the creative photographer as a master of rhetoric appears today irretrievably outdated. The quest for formal 'balance' à la Stieglitz or Cartier-Bresson has largely retreated, and with it the photographer's discourse has relinquished the Symbolist posture. The great photographer may indeed have a voice, but his/her ascension to cultural

64 Elizabeth Lennard, *Maman, Baby, Belley* (Le Bugey), 1996, black-and-white silver gelatin print with oil colour and graphite.

Around the border (clockwise from top):

AND OXEN AND WALLS OF A PART OF a building which is up. TREES VALLEYS

FIELDS FLOCKS AND BUTTERFLIES AND PINKS AND BIRDS, THE BEAUTIES OF

NATURE HILLS VALLEYS TREES FIELDS AND BIRDS... GERTRUDE STEIN

TREES FIELDS HILLS VALLEYS BIRDS PINKS BUTTERFLIES CLOUDS

stardom makes the use of that voice largely irrelevant – even unwanted – or a mere concession to institutional demands, as in the case of Cindy Sherman's 2001 retrospective. As evidenced also by the work of Sherman, the former taste for 'dense', literary-sounding captions has yielded, as in much modern art, to the ubiquitous 'untitled' label. Today the function of speech and commentary is devolved rather to the great photo-illustrator, exemplified by the aerial photographer Yann Arthus-Bertrand, who to all intents and purposes has taken the place occupied one century earlier by popular writers such as Jules Verne. Digital photography, among other mixed blessings, has meanwhile helped uproot the old Realist credo which Barthes clung to in 1980; while postcards are being phased out by email attachments and file-sharing websites, fiction is today widely considered a standard field for photography, from Andreas Gursky to 'the blogosphere'. Significantly, Susan Sontag in her last book (*Regarding the Pain of Others*, 2004) admitted postmodern scepticism into her critique of the voyeurism of war, while appealing to a great modernist – Virginia Woolf – as a witness of photography's powers of manipulation. As shown by the career of Jean Baudrillard, the postmodern critique of simulacra has incorporated the practices of performing, theatricality, appropriation, or mimicking, understood as weapons against conformity in the visual arts and academic discourse. Meanwhile, a formerly 'documentary' photographer such as Martin Parr has been able to pursue radical experiments while publishing softened versions of them in mainstream presses and museums as well as corporate strategies, making postmodernist photography palatable to middlebrow audiences. Even though a lot of its traditional social uses remain seemingly untouched, photography's historic alternative as a medium – to supplant literature, or to become a new literature – would seem to have been resolved in favour of the second term, especially given, as we shall see in the final chapter, literature's own marriage to photography.

65 Jeff Wall, *After 'Invisible Man' by Ralph Ellison, the Prologue*, 1999–2000; transparency in lightbox.

The Photography of Literature

That the outer man is a picture of the inner, and the face an expression
and revelation of the whole character, is a presumption likely enough in
itself, and therefore a safe one to go by; evidenced as it is by the fact that
people are always anxious to see anyone who has made himself famous
by good or evil, or as the author of some extraordinary work; or if they
cannot get a sight of him, to hear at any rate from others what he looks
like. So people go to places where they may expect to see the person
who interests them; the press, especially in England, endeavors to give
a minute and striking description of his appearance; painters and
engravers lose no time in putting him visibly before us; and finally
photography, on that very account of such high value, affords the
most complete satisfaction of our curiosity.

Arthur Schopenhauer, 'Physiognomy', 1851[1]

The history of literary responses to photography can usefully be
envisioned as a history of 'discoveries', as I called them in chapter Three.
The subject, however, is much broader, and since the 1980s an increasing
number of anthologies and monographs have scrutinized literature's
practical relationships to photography and the visual. Though often
marred by national limitations, such studies have enriched our under-
standing in substituting for the previous history of opinions – often static
and merely ornamental – a history of 'interactions' between literature
and photography, to use Jane Rabb's phrase.[2]

Paul Valéry's 1939 'parallel' between the advent of photography and
that of the 'descriptive genre', for instance, has taken the proportion of an

66 Unidentified artist, *Portrait of
Frederick Douglass*, 1856, ambrotype.

113

epistemic link between the realist novel and the photographic construction of reality. Carol Armstrong suggests that Victorian and modern British fiction as a whole was permeated by the advent of mass visuality, while Jennifer Green-Lewis postulates an even broader synergy between photography and the Victorian choice between romance versus realism.[3] Earlier Carol Shloss had shown to what an extraordinary extent American writers have incorporated optical and photographic experiences into the basic topics and modes of fiction.[4] In France, Philippe Ortel has claimed that photography determined an 'invisible revolution' in literature by creating a new 'framework' that, whether explicitly acknowledged or not, invaded the codes, topics, and functions of fiction; as he notes, in the nineteenth century photography is 'everywhere and nowhere', meaning that whether or not writers explicitly registered opinions about it their work was affected by its ubiquity.[5] Conversely, Jérôme Thélot has claimed for literature a crucial share in 'inventing' photography, in writing it into fiction or poetry and thereby 'giving meaning' to it.[6] My approach in this chapter is at the same time more limited and broader. It is more limited in the sense that I do not attempt to describe the vast spectrum of modern literary practices that reflect, incorporate, register or deconstruct the social impact or the poetic force of photographs, but concentrate on representations of literature (and writers) through photography. It is broader, however, in that at the same time I am trying, in this final chapter, to bring to a conclusion the discussion opened in the previous ones about the large-scale reshuffling of cultural functions between literature and photography. As we shall see, the increasing theatricality and declining eloquence of photography in the late twentieth century have been matched by the increasing penchant of literature for photography; perhaps the main achievement of the contemporary period is the successful hybridization of the two mediums.

The advent of photography must not be considered merely an external or a late circumstance in an evolution process of literature construed as independent and already consolidated by 1840; on the contrary, from a socio-historical viewpoint, the invention of photography was largely concurrent with the emergence of literature as a commodity and a cultural

M. B. BRADY'S NEW PHOTOGRAPHIC GALLERY, CORNER OF BROADWAY AND TENTH STREET, NEW YORK.—See Page 166.

67 A. Berghaus, 'M. B. Brady's New Photographic Gallery', engraved illustration in *Frank Leslie's Illustrated Newspaper*, 5 January 1861.

language of modernity, reflected by the fashioning of the writer figure as cultural value. If photography contributed to a larger trend of publicization and visualization of the private, the emergence of the writer's cultural and commercial value from the mid-nineteenth century on was in particular supported by the spread of his/her public image. The circulation of authors' portraits in the era of mass (engraved) illustration and then the *carte-de-visite* played an important part in this development. Writers (and artists) from the 1840s to the 1900s thus witnessed, with varying reactions, the relatively sudden accession to visibility of their faces and bodies through photography and engraving. This new social currency joined in the larger visual gallery of public figures that self-styled photographic historians à la Brady or Nadar and firms such as Disderi's offered for contemplation and collection.

I want to go back to the so-called phenomenon of literary 'ambivalence' to photography, to suggest that for many writers, guarded behaviour was guided not only by frustration with their photographic images but by a more political reaction against the pressure to have their faces publicized. A good example is Herman Melville, who in *Pierre, or the Ambiguities*, had his title character turn down – as Melville had done himself – a publisher's request for a portrait with this declaration of aristocratic taste: 'Besides, when every body has his portrait published, true distinction lies in not having yours published at all.'[7] Frederick Douglass, who early on became keenly aware of the expediency of broadcasting an appealing image of himself, linked the twin issues of pictorial unpredictability and iconic power when he exclaimed, in a 1861 lecture on 'Pictures and Progress', that

> a man who now o'days publishes a book, or peddles a patent medicine, and does not publish his face to the world with it may almost claim and get credit for simpler modesty. Handsome or homely, manly or mean, if an author's face can possibly be other than fine looking the picture must be in the book, or the book be considered incomplete.[8]

Emily Dickinson, while surrounding herself with photographs of fellow writers, refused to give her publisher a portrait of herself and openly debunked the accepted wisdom that such a portrait could and should serve as an adequate image of a writer's 'interiority'.[9] John Ruskin consistently grumbled at having his portrait taken, even when, as Jane Rabb notes, the photographer was his fellow Oxford teacher and friend Lewis Carroll.[10] Gérard de Nerval, although he had attempted the daguerreotype on his Oriental voyage in 1843, remained suspicious of photographic portraits and, shortly before his suicide, asked that a particularly disgraceful daguerreotype image of himself be regarded as 'posthumous', while dedicating to Nadar a poem on the transmutation of metals which warned modern engineers not to force matter to serve an 'impious use'.[11] Flaubert consistently refused to be photographed. While some writers, such as Hawthorne, willingly posed and supplied portraits of themselves, it does seem that the majority suffered from the tension that Helen Groth

68 Charles Hugo and Auguste Vacquerie, *Victor Hugo on the Rock of the Exiles*, 1853, salted paper print.

records in English Victorian poets, on the one hand appalled by 'the alienating effects of mass production' and 'the notion that their names, faces, and lives could become commodities', on the other involved by necessity in feeding 'the publicity machine by being photographed'.[12]

Some writers, however, for whom iconicization and publicization of their selves seemed quite welcome, took an active part in the picture-making or in the circulation of images and thus willingly contributed their own images to the ongoing redefinition of literature's public role – indeed to the elevation of literature to the status of a new religion. Two prime examples, almost exactly contemporary and similar in many respects, are the poets Victor Hugo in France and Walt Whitman in the

USA. When the French poet, already a national figure and a Republican symbol, went into exile in the Channel Islands after Napoleon III seized power and restored the Empire, he and his family, especially his son Charles, immediately took up photography. They were to invest an extraordinary amount of energy in it over the next decade.

Photographing sights on the island of Jersey, family groups and scenes, Charles Hugo and his partner Auguste Vacquerie repeatedly immortalized – here the word is no cliché – the great writer, not only in portraits but in carefully staged compositions showing him, as in several versions on 'the Rock of Exile', in the posture of the solitary Romantic facing the sea and offering himself as allegory. The hero of an epic resistance against tyranny and mediocrity, but also the priest of a new cult – the 'Hugo religion', as Jérôme Thélot terms it – the poet definitively associated, in these highly self-conscious photographs, Literature, Freedom, and Progress.[13] Hugo, who until then had been very discreet on photography, now believed in a 'photographic revolution' waged 'in collaboration with the sun'. 'Solem quis dicere falsum audeat?' ('Who would dare call the Sun false?'), he wrote to Flaubert in an 1853 letter that included a portrait of himself. Better known since an important 1999 show at the Musée d'Orsay, the hundreds of photographs thus composed (on a daily basis) during the stay at Jersey (and to a lesser degree at Guernsey after 1855) constitutes, writes Jane Rabb, 'the most intensive photographic record of any nineteenth-century writer.'[14] This is a record which, considering its highly theatrical dimension, 'could almost be called an enterprise in collective autofiction'.[15] There is much evidence that these photographs were intended originally to serve as illustrations for the numerous literary projects that Hugo, in a creative frenzy, worked on at Jersey: tipped-in prints of the exile tableaux were used in at least five copies of a private edition of Hugo's major poetic autobiography, *Contemplations* (1856), and similar projects were envisioned but aborted for lack of funds.[16] Although their contemporary diffusion was limited to friends and Parisian literati, these ventures decisively inaugurated not only the promotional usage of a writer's image (which, in the case of the Jersey photographs, remained mostly a wishful idea, Hugo dreaming of 'diffusing [the idea of] diffusion', as Thélot puts it, rather than actually

69 After Gabriel Harrison, 'Walt Whitman Dressed in Rural Attire', 1854; steel engraving from photograph for frontispiece of the first edition of *Leaves of Grass* (Brooklyn, New York, 1855). Signed by Whitman, 1855.

70 Phillips & Taylor, *Walt Whitman Holding a Butterfly*, 1873, albumen print signed by Whitman.

succeeding in it) but the photography of literature as a cultural force linking poetry and science in the service of a liberation of mankind.

In 1855, exactly at the same time as Hugo was working on the publication of his *Contemplations*, the first edition of *Leaves of Grass* appeared in New York, which in lieu of an author's name included an engraved frontispiece with a full-length portrait of Walt Whitman in 'bohemian' dress, a picture (by Gabriel Harrison) that contrasted with the usually staid style of authors' busts. This image, which would establish the figure

of the American poet and reverberate it at least down to the beat
generation, was the first of several photographic frontispieces used by
Whitman and one among many portraits (probably over a hundred) that
make Whitman the most photographed major writer of the century, as
well as the most 'photophile'.[17] As a young journalist in New York Walt
Whitman had repeatedly described his visits to photographers' galleries
and his exalted musings at their exhibitions of portraits – 'a new world –
a peopled world, though mute as the grave' yet telling 'a thousand human
histories'.[18] Whitman indeed kept abreast of photography as both a well
of popular romance and a source of information, particularly during the
Civil War. But above all he regarded it as an allegory of literature in its
rhetorical and political functions. While several of his poems testify direct-
ly to his wish to emulate photography as an unprejudiced, democratic
and 'quintessentially American' art (as Rabb indicates), the famous late
piece titled 'Out from behind this mask' (1876) was specifically meant
'to confront my portrait' (as a wound-dresser during the Civil War) and to
'emanate . . . a Look' for the viewer-reader. Like Hugo, but in more durable
fashion, Whitman was genuinely fascinated by the medium's facility for
procuring and diffusing not only images of himself (which he scrupulously
kept, as they became popular collectibles) but also, through this allegorical
mediation, a picture of Literature and its mission to enlighten and redeem
the world.

Though the relevance of such a mission came into question with later
generations, the Hugolian 'revolution' – the metamorphosis of the writer
into a national and universal heroic image – which was amplified after
Hugo's death, left its mark on many of his successors. Later in the nine-
teenth century, writers as diverse as Thomas Hardy, Émile Zola, Oscar
Wilde (today regarded as a major pioneer of 'self-invention')[19] or Leo
Tolstoy ('one of the most photographed figures of his time in Russia')[20]
all showed a concern for their image by participating in highly concerted
portrait productions and publications. Even some confirmed photo-
phobes privately indulged in photographic tableaux of themselves, as in
Edgar Degas's famous portrait of Stéphane Mallarmé posing before a
mirror in the company of Auguste Renoir (one of several artist friends,
along with Degas and Manet, who reconciled the poet with pictures and

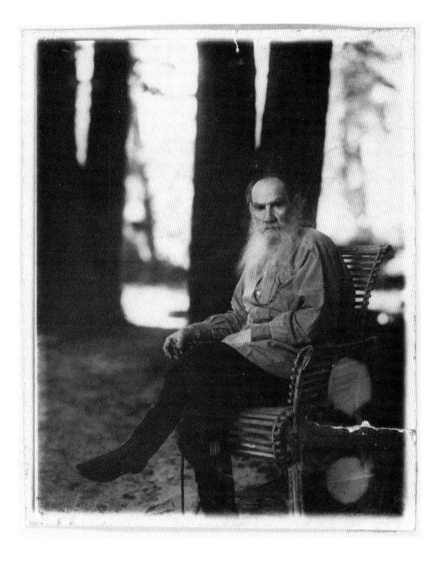

71 Sergei Mikhailovich Prokudin-Gorskii, *Leo Tolstoy at Yasnaya Polyana*, 1908, gelatin silver print from album.

his own image after his early and prolonged 'crisis' had made him, according to Thélot, associate photography with the haunting experience of nothingness).[21]

After 1880 the growing field of amateur photography attracted some writers and intellectuals, though many of those, following an earlier pattern of discretion, kept their photographic practice a private matter.

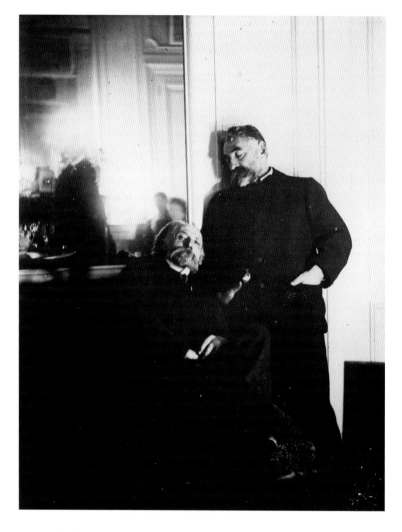

Zola, who as a champion of Naturalism had claimed photography as a model for literary 'reproduction', and whose writing techniques were permeated by the logic of experimental observation, had largely ceased writing when he took up photography in earnest in the late 1880s.[22] Though his very deliberate photographic practice, conducted with 'serious' rather than amateur equipment, can be seen as consistent with his systematic protocols for fiction, the larger battle against social injustice

73 Emile Zola, *Portrait of Denise in a White Lace Dress*, between 1900 and 1902, silver print.

74 Alfred Stieglitz, 'Katherine', 1905, photogravure print published in *Camera Work* XII (October 1905).

that informed much of his public life tends to fade from view in his imagery, which remained mostly private and can be seen in large part as intimate, sentimental, and stylistically pictorialist. Zola's photographs of his daughter are reminiscent of Alfred Stieglitz's portraits of Katherine, which is something of an irony in view of the American photographer professing the influence of Zola's novels on his choice, in the 1890s, of 'low' subjects. Similarly, Zola's images of the writer's interior (his desk, etc.) appear less today as detached 'observations' than as complacent self-representations. In the same period, the American patrician historian and novelist Henry Adams and his wife Marian Clover Adams spent considerable amounts of time and care producing and commenting on their own photographs, from the time of their honeymoon in 1873 to Marian's

suicide in 1883 – by means of photographic cyanide potassium – and in later life Henry took up photography, again privately, all the while descrying it in his writing.[23] Later in the twentieth century, the practice of photography by writers – from Giovanni Verga, G. B. Shaw, J. M. Synge or the young William Faulkner, to Jerzy Kozinsky, Richard Wright or Michel Tournier – became almost banal, though in most cases it did not come to light or prominence until the 1970s or '80s, as in the example of Eudora Welty, long known as a storyteller before her photography of the rural American South in the 1930s was publicized.[24]

If the photographic practice, and especially the self-representation, of writers thus remained largely a private matter until about 1980, their iconicization continued to expand through the twentieth century. After 1900, modernist writers from Marcel Proust and Ezra Pound to James Joyce, Italo Svevo and Maxim Gorki, plus the whole Surrealist group, routinely posed for photographers, now often artist photographers, in increasingly self-conscious and technically ambitious portraits (see for example Man Ray's *Album du Surréalisme*). Many of the classic images of the 1920s and '30s identified by standard photo-histories are portraits of writers by Man Ray, Alexander Rodchenko, Robert Capa, Gisèle Freund, Brassaï and other photographers, who often became public figures as well and sometimes literary personae, as in the case of Brassaï, who was fictionalized by Henry Miller in *Tropic of Cancer*. In the 1940s, '50s and '60s, André Kertesz, Henri Cartier-Bresson, Youssouf Karsh, Richard Avedon and others would complete the writer's photographic stardom, just as, with Truman Capote, Ernest Hemingway, Jean-Paul Sartre or Yukio Mishima (all adepts, in various ways, of propagandistic uses of their own images), the figure of the writer attained perhaps maximal exposure, often linked to political commitments and epic achievements. In the decades following World War II the mainstream picture press greatly contributed to the iconicization of writers by regularly featuring their portraits, their interiors and sometimes their hobbies or vacation habits. The death of the great writer (already an image when Man Ray photographed Proust on his death bed) was now an occasion for grandiloquent front-page layouts.

In the same period, the earlier trend of photographers testifying, like Nadar or Brady, to their 'historic' acquaintance with great literary figures

75 Emile Zola, Library with a Portrait of Emile Zola and his Father in 1845, c. 1900, silver print.

77 Gisèle Freund, *James Joyce with a Magnifying Glass, Paris*, 1939, colour print.

76 Alvin Langdon Coburn, *Vortograph of Ezra Pound*, 1917; gelatin silver print.

took on a more explicitly literary turn, as some photographers became, or came to be considered, the established memorialists of writers; Gisèle Freund in her reminiscences (*Three Days with James Joyce* and *The World in My Camera*), Brassaï in his studies of Lewis Carroll and Marcel Proust (the latter posthumously published) and Richard Avedon in his comments

on writers' portraits, are classic examples.[25] By 1970, as the public image of the writer had become a staple of literary publishing and social columns, many serious writers continued Dickinson's and Mallarmé's resistance to photography by refusing to engage in any portraiture (or transaction with the press). Some (such as Julien Gracq, René Char and

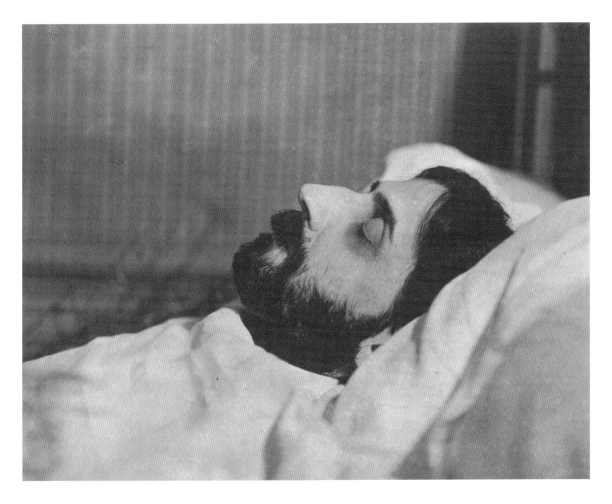

79 Man Ray (Emmanuel Radnitzky), *Marcel Proust on his Death-Bed*, 1922, silver print.

Thomas Pynchon) opted for total withdrawal from the public sphere, thus implementing what Paul Virilio would call an 'aesthetics of disappearance'.[26] Others chose a more ambiguous stance by offering explicitly unconventional, demystifying, or even slightly crude images of themselves. Such gestures, however, remained relatively insignificant in the face of the growing hybridization of photography, literature and performance that I want to conclude with.

Since the nineteenth century, concurrent with the project of imaging the writer's face had been that of illustrating his or her work, and this

larger branch of the emerging industry of photographing literature
was often exposed to the same ambivalences we have been discussing.
Whether revisiting classics, or embarking on original projects, photog-
raphers and writers were collaborating well before 1900 – mostly in
English-language publications. A singularly precocious case was
Nathaniel Hawthorne. One of the very first major fiction writers to centre
a novel on the character of a photographer (*The House of the Seven Gables*,
1851), Hawthorne was again innovative in publishing *The Marble Faun*
(1860), his last major work, in a luxurious Tauchnitz edition illustrated
with 57 tipped-in albumen prints from commercial tourist images.[27] The
German publisher had been for some time publishing illustrated English
and American classics for the English-speaking tourist market on the
continent, and would issue a photographic edition of George Eliot's
Romola in 1863. Hawthorne's book became as durable a classic of Italian
travel as any guidebook, and was reissued in several other illustrated
editions before the end of the century. The Tauchnitz volumes thus
helped set a broader publishing pattern, flourishing in England after
1860. Several photographer-publishers, notably George Washington
Wilson and Francis Frith, made a speciality of producing illustrated
editions and holding public recitations of poets such as Longfellow,
Walter Scott, Robert Burns and even Wordsworth. As we saw in chapter
Two, Frith used the photographic book, starting with his *Egypt and
Palestine Photographed and Described*, as an arena for enunciating photo-
graphic style and authorship; in 1864 Frith and Co. started a 'Gossiping
photographer' series, and in the preface to his illustrated edition of
Longfellow's *Hyperion* (1865) the photographer pointedly discussed
photography's relationship to the modern taste for romance.[28]

In the same general context, but in a very different stylistic vein and
ambition, belongs the photo-literary career of Julia Margaret Cameron,
who, closely allied with many of England's prominent writers and
intellectuals, began work on illustrating Tennyson's poetry (especially
his *Idylls of the King*) as soon as she started photography in earnest in
1864. Though the contemporary reception of Cameron's often poignant
portraits denigrated their photographic realism as inappropriate to
legendary and imaginary subjects, and though her literary ventures were

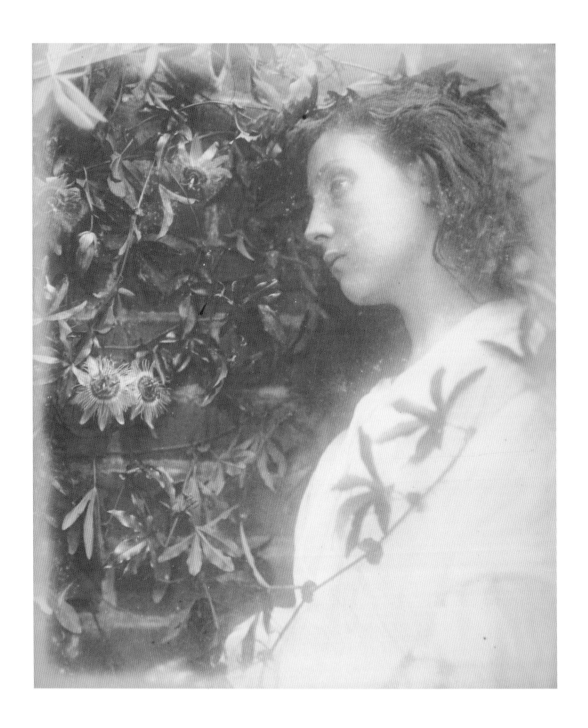

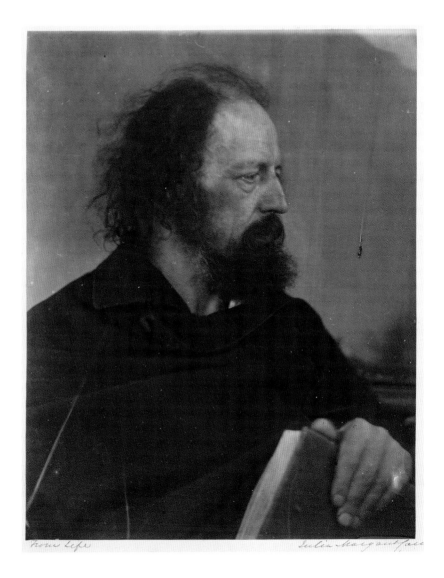

81 Julia Margaret Cameron, *Maud the Passion Flower at the Gate*, in *Julia Margaret Cameron's Illustrations to Tennyson's 'Idylls of the King' and Other Poems* (London, 1875), albumen print.

82 Julia Margaret Cameron, *A. Tennyson*, 1865, albumen print inscribed 'From Life'.

financially disastrous, recent criticism has commended her anti-positivist spiritualism and her creative use of light and shadow as befitting Tennyson's strongly visual imagination (as shown also by her portraits of Tennyson, Thomas Carlyle or John F. Herschel).[29] The same coalescence of visual imagination, literary and photographic experimentation

83 Two-page spread with half-tone reproduction in Georges Rodenbach, *Bruges-la-Morte* (Paris, 1892). Photographer unidentified.

also characterizes the work of Lewis Carroll – another familiar figure in the Cameron circle – in the 1860s, although the logician generally did not use photographs for illustrations in his published writings, and although the plot and illustrations of *Alice's Adventures in Wonderland* (1865) are more reminiscent of Cyrano de Bergerac's 'extravagant conceptions' than of Tennyson's and Cameron's modernized Arthurian imagery. In his story 'Photography Extraordinary' (1855), Charles Dodgson had invented a utopian method for, quite literally, photographing literature, through the fiction of a magical paper automatically printing out various versions of a poem as they suggested themselves to a poet's mind.[30] Carroll in his juxtapositions of the fictional and photographic Alices, Cameron in her Arthurian imagery and her portrait work, and their circle (not unlike their heir, the Bloomsbury group) thus showed that photographing literature was possible and indeed aesthetically relevant – even as the genteel opinion of the times, sometimes shared by members of the group themselves, found the project insulting to the very idea of literature.[31]

By no means, then, can it be maintained that the first work of fiction illustrated with photographs was Georges Rodenbach's *Bruges-la-Morte*. An elegiac portrait of the Belgian city first published in 1892 (with similigravures based on originals supplied by photographic firms), *Bruges-la-Morte* has been regarded as a relevant influence on writers from André Breton to W. G. Sebald and Yasunari Kawabata.[32] Indeed, this singular book was a milestone in a larger publishing fad, in turn-of-the-century France, of photomechanically illustrated novels, especially of a popular kind – a fad that prompted the *Mercure de France* magazine to launch an opinion survey in 1898 among writers 'on the novel illustrated

84 'The bookstore of *L'Humanité*', a half-tone reproduction of a photograph by Jacques-André Boiffard in André Breton, *Nadja* (Paris: Gallimard, 1928, a reprinting of 1958).

80 NADJA

il bien passer de si extraordinaire dans ces yeux ? Que s'y mire-t-il à la fois obscurément de détresse et lumineusement d'orgueil ? C'est aussi l'énigme que pose le début de confession que, sans m'en demander davantage, avec une confiance qui pourrait (ou bien qui ne pourrait ?) être mal placée elle me fait. A Lille, ville dont elle est originaire et qu'elle n'a quittée qu'il y a deux ou trois ans, elle a connu un étudiant qu'elle a peut-être aimé, et qui l'aimait. Un beau jour, elle s'est décidée à le quitter alors qu'il s'y attendait le moins, et cela « de peur de le gêner ». C'est alors qu'elle est venue à Paris, d'où elle lui a écrit à des intervalles de plus en plus longs sans jamais lui donner son adresse. Près d'un an plus tard, cependant, elle l'a rencontré à Paris même, ils ont été tous deux très surpris. Tout en lui prenant les mains, il n'a pu s'empêcher de lui dire combien il la trou-

Pl. 17. — La librairie de *l'Humanité*.

page 77

by photography'.[33] *Bruges-la-Morte* marked a threshold in embodying, in distant echo to Talbot's *The Pencil of Nature*, a reflexive investigation on the 'illustrative' medium of photography, here interpreted, as Paul Edwards has shown, as a purveyor of relics, ideally suited to sustain the description of a 'dead' city that itself served as scenery for the quest for the dead beloved. In fact, Rodenbach anticipated much of the later discourse on photography's connections to death, perhaps more than it did André Breton's 'anti-descriptive' use, in *Nadja* (1928), of the photographs of Jacques-André Boiffard, Man Ray and others. In this prototypal Surrealist novel, Breton presented the photographs as at once 'objective', 'neutral' or anti-literary images of city sights or human faces, and as signed, authored reflections – by others – of the narrator's 'special angle' on these sights in his search for the elusive Nadja.[34] *Nadja*, which encompassed in the form of a novel the inspirational power the Surrealists found in photography (as with automatic writing),[35] was a landmark, and in France at least the notion of substituting photographs for descriptions was regarded as a novelty.

A decade later, in his centennial speech, Paul Valéry would wonder at the possibility that photography might 'restrict the importance of the art of writing' by discouraging one from 'describing what [it] can automatically record';[36] and in 1940 the French historian of photography Georges Potonniée would quote this speech in his singular chapter on 'photography, a literary process', where he listed 'teaching' and 'recreation' – especially in the form of cinematographic 'drama' – as the main avenues of this overlooked use of photography, destined in his eyes to palliate the powerlessness of words 'to create an image'.[37] Breton, however, had been preceded in the 'authored illustration' mode, if not by Francis Frith and Julia Margaret Cameron, at least by Henry James. In 1904, indeed, the 'old lion' had asked the avant-garde pictorialist photographer Alvin Langdon Coburn to illustrate the complete 'New York' edition of his fiction, signalling a momentous shift in the division of labour between photography and serious literature. Previously James had made no mystery of his iconophobia and his distaste for the 'illustrative' credo of modern literary publishing, which he saw as contributing to the decline

of literature. In the context of 1905 the systematic introduction of

85 Alvin Langdon Coburn, *View of Williamsburg Bridge*, c. 1911, photogravure in *New York* (London and New York, 1911).

photographic illustrations in the definitive edition of the English language's foremost modern writer rang as both an act of deference to the publishing trade and as a significant stage in the legitimization of photography as a sister art to literature. In addition it could be read as an attempt on the part of a champion of literature to capitalize on photography's rising star. It is striking that James, who did not believe in 'art photography', not only instructed Coburn about subjects to be depicted – mostly for 'atmosphere', rather than specific narrative detail – but enjoined the

photographer, whom he clearly admired, to develop a personal, peculiar 'view' of them; in return Coburn (whose Jamesian assignment is not today considered among his best work) spoke highly of James's 'photographic' style of observation.[38]

In both James's and Breton's cases – and in spite of obvious differences – the fact that the photography was explicitly referred to photographic *signatures,* as opposed to mere illustrators, suggested that modern collaborations no longer obeyed the 'survey' structure, or Frith's complacent photographic 'gossiping', and instead reflected parallel aesthetic researches. In modernist circles from New York to London, Berlin and Moscow, as well as among the Dada and surrealist groups, such parallels became almost banal by 1930, and they formed an aesthetic context for the rise of the photo-essay discussed in chapter Two. Although the photo-essay in the documentary vein occupied much of the ground of photo-literature from the 1940s to the '60s (now almost systematically coupled, as we have seen, with prefaces or commentaries by non-photographer writers), a minor trend of original illustrated literature continued to exist in this period, as in Breton's *L'Amour fou* (1937) and Jacques Prévert's and Izis's *Charmes de Londres* (1952). Meanwhile, the increasing popularization of photography as a cultural and artistic force led to countless photographic revisitations of classic oeuvres, some becoming landmarks of their own. Edward Weston's illustrations of Whitman's *Leaves of Grass* or Herbert W. Gleason's photographic recreations of Henry David Thoreau's travel and natural history works in the 1960s are two examples, while the 1970s and '80s saw several photographic explorations of Proustian sites and scenes, notably by Jean-François Chevrier and Xavier Bouchart.[39] Though somewhat eerie, Sarah Moon's *Little Red Riding Hood* (1993) has become a popular version of the tale. In the early twenty-first century the by now traditional juxtaposition of (authored) photographs and texts is widely practised by literary magazines, such as the *New Yorker* in its 'Fiction' column. Still, the notion of *illustrating* literature is rather on the wane since 1970, as the photographic image has increasingly assumed the role of *participating in* or indeed *embodying* literary projects, in keeping with the evolution of many

creative photographers towards performance and fiction. As early as 1961, Roland Barthes had noted that the modern 'photographic message' no longer illustrated the text, which conversely tended to become a commentary or 'parasite' of the image.[40]

The broadly postmodern *rapprochement* of literature and photography, perhaps identified best in the literary and critical work of W. G. Sebald, can only be briefly examined here. What needs stressing is that it has largely succeeded, at least with the literary and cultural avant-gardes, in displacing the traditional association of photography with realism and a neutral or impersonal memory apparatus, or at least embedding it deeply in a form of literature that is simultaneously resolutely fictional and explicitly autobiographical. This shift towards 'autofiction', a genre of fictionalized autobiography that – often accompanied by photographs – came to be recognized as such around 1980 in France, was announced in various works by *nouveau roman* authors (among them Alain Robbe-Grillet and Claude Simon) and in some ways illustrated by Barthes's *Camera Lucida*.[41] This was claimed by Sebald, though in a different vein, as necessary in the wake of the twentieth century's disastrous human record and the need for reconstructing personal as well as public remembrance in non-didactic ways. It has been powerfully supported by contemporary art photography trends, from Christian Boltanski to Sally Mann, Nan Goldin or Gerhard Richter.

In France, autofiction has taken a considerable place on the literary scene itself and within its most respected publishing houses – such as Gallimard. One pioneer was Michel Tournier, who, however, tended to remain confined to the illustrative mode. The brief career of the photographer, writer and critic Hervé Guibert was a decisive stage; his first major published project was *Suzanne et Louise* (1980), a family narrative illustrated with photographs of the young writer-photographer's two great aunts, which played at exploiting and redefining the popular genre of the *roman-photo*. The following year Guibert published a kind of literary self-portrait titled *L'Image fantôme*, comprising a collection of reminiscences – written and not illustrated – about photography and photographs. His later works (published by Gallimard) usually did not include photographs, and largely consisted of diaries and narratives of

and about the representation of his increasingly painful life and the approach of death from AIDS, which he also documented in photographs and films. Photo-narratives by writer-photographers such as Denis Roche or Alix Cléo Roubaud have been largely centred on the theme of the photographer's 'absences', or creative abstentions. The *roman-photo*, formerly a pulp genre, has been evolving towards highbrow status, as shown, beyond Guibert's example, by the collaborations of Benoît Peeters and Marie-Françoise Plissart.[42] These trends have paved the ground for an explosion, in French literary publishing, of illustrated 'autofiction', especially by women writers (Anne-Marie Garat, Annie Ernaux and Christine Angot, among others). No matter how wordy, even verbose, this trend may seem, at the same time it does not contradict the postmodern aspiration of photography to silence: in much autofiction the photographs are not used as illustration in a connected 'photo-text' but instead as further evidence – almost in a forensic sense – of a process of decomposition by the subject (and therefore the text).

Meanwhile, many French philosophers and intellectuals turned, in the 1980s and '90s, to the critique and the history of images (occasionally publishing, like Régis Debray, illustrated volumes themselves). The sociologist and essayist Jean Baudrillard, however, who first reached public status with celebrated debunkings of the 'systems' of fashion or objects, later combined his well-known critique of 'the disappearance of reality' with photographic and autobiographical publications, ending his prolific career by being known also as a photographer and an influential writer on photography.[43] While these various hybridizations of literature with photography have attracted commercial success and critical attention, it is too early to tell whether they signal a durable pattern, especially as cyberliterature starts to offer another, more radical, alternative to traditional fiction writing. Certainly the blogosphere offers much in the way of photographic autofiction. What is unquestionable, however, is that beneath the changing fashions of the publishing market a global shift has definitely reduced the old estrangement of photography from literature. In the early twenty-first century, even as creative photography has mostly renounced its symbolist alliance with literary rhetoric, the 'pencil of nature' has become, more than ever before, a familiar tool of writers.

86 Hervé Guibert, untitled photograph, 1980s, gelatin silver print.

Conclusion

It is tempting to close this book with a bold verdict: if poetry was for Baudelaire a refuge of the imagination against the inroads of photographic and other modern vulgarities, in the age of Barthes, Baudrillard, Sebald, and Sherman photography has become a new muse of literature – or perhaps one of the driving forces behind the 'eviction of literary speech'[1] – and a principal weapon in the critique of the very reality it was once supposed to certify. Unquestionably, at the beginning of the twenty-first century the interpretation of photography as 'writing with light' has gained credence at the expense of its older gloss, equally fanciful but once compelling, as 'sun painting'. What is more, the aesthetic and epistemological model of (truthful) representation that underlay the former etymology has by and large yielded to a definition of art as (subjective, historical, economic, social) production – a definition the 'digital turn' has only boosted further. Such a clear-cut conclusion, however, would be far too simplistic, and I wish to end with some words of methodological and historical caution.

In my introduction I wrote that one of the original claims of this book was to attempt to address its topic from the point of view of photography, rather than taking literature's priority for granted and assessing its ability to 'make sense' of photography. I believe chapters Two and Four particularly illustrate this claim, retracing some of the steps by which serious or concerned photographers devised suitable modes and genres of self-expression and more generally of photo-textual production. As I warned, however, seeking to espouse photography's point of view is a slippery path, since, today as yesterday, no clear consensus delimits the area of its

87 Cindy Sherman, *Untitled Film Still #13*, 1978, gelatin silver print.

143

extension – or even of its 'relevant' uses. I maintain the thesis of my earlier book, that is, the notion of a global 'learning' or de-popularization of the medium.[2] A shift, that is, to highbrow status, one symptom of which is precisely the modernist and postmodernist taste for photography, another being its canonization as an academically sanctioned expression of subjective singularity. Yet I certainly do not consider this shift to have prevailed equally in every aspect of the ubiquitous practice(s) of photography and images, nor do I suggest that all contemporary photography is 'literary'. It is questionable whether mail-order catalogues and police files of 2000 are more 'literary' than those of 1930 or 1880. Amateur photography, still regrettably understudied, seems to me no more or less 'literary' than it was in 1960 or 1920. There certainly exist interesting echoes between, say, the practices of postcard correspondence, photographic play or diary illustration after World War 1 – often highly erudite – and the contemporary economies of email and blogs, today's primary vectors for the circulation and the commentary of images. Incidentally, a full-fledged exploration of *captioning*, especially in amateur photography, would

probably shed much light on the literary imaginations and aspirations of photographers. And here I must acknowledge my own limitations. As this book aimed at a synthesis rather than a wholly novel investigation, it has tended to endorse accepted hierarchies more than would be suitable to an authentically 'photographic' account. Many subjects touched on in this book beg for further, innovative research. Nonetheless I hope to have made a step in the right direction, and especially towards acknowledging the contribution of photographers to literature, as opposed to the better-known literary accounts of photography. Incidentally, a similar criticism applies to the international dimension of my account; it attempts to gather several threads – European and North American, for the most part – but fails to consider other important areas, especially Asian and post-colonial, which would be necessary to warrant general conclusions.

In addition, the very idea of a global status change of photography – especially towards compatibility with literature – must be questioned precisely to the extent that it is seductive. Ideally, I would like to have shown that a shift has occurred, resulting in previously unthinkable photo-literary oeuvres, such as Hervé Guibert's, and bringing to the fore photography's affinities with various aspects of the broad territory I have called 'literature', especially writing, narrative and fiction. In my view, however, this shift does not separate two or more radically distinct 'eras', construed as contradicting one another; in other words, my goal has been to do history without historicism. As a specialist of the nineteenth century, I have consciously laid much emphasis on the earlier 'interactions' of photography and literature, no doubt at the expense of the later manifestations. But this choice was also meant to refute a common opinion, according to which photography would only have been truly 'discovered' or 'understood' in later stages of its development – whether in the 1900s, the 1930s, or the 1970s – after being shrouded or simply utilized by a hopelessly stupid nineteenth century, ensconced in unpalatable ideologies of positivism, utilitarianism or surveillance. I am struck by the fact that Michel Foucault, doubtless an expert on the history of surveillance, almost never mentioned photography in this connection and reserved one of his rare comments on the history of photography to the composites of Rejlander and Henry Peach Robinson, which he saw as experiments in

photographic freedom or 'play', anticipating fictional games of the 1970s.[3] Similarly, and more generally, I consider that much of the critical wisdom received in the late twentieth century about photography, and described then as novel, was aptly articulated in the first decades of the medium; witness, especially, the texts by Lady Eastlake and Oliver W. Holmes previously discussed.

It is doubtless difficult to reconcile the idea of an epistemic shift – largely inspired, in this book, by Foucault's model – with such examples of permanence, and indeed with the notion of 'anticipation' itself. Yet, following Foucault's example, I try to overcome this paradox by locating the shift not primarily on the plane of 'ideas', that is, contents, but in the social circuits of discourse and the productive practices they accompany, justify, try to describe or manage to cover up. The fact of the matter, in both Holmes's and Eastlake's examples, and even to a large extent in Baudelaire's, is that their contributions to the cultural knowledge of photography were more or less entirely ignored until, at the earliest, the 1930s. This fact undoubtedly limits their historical significance, but it does not allow one to consider later reformulations as 'discoveries', nor their original statements as mere 'anticipations'. What emerges from the confrontation of Eastlake or Holmes to Benjamin or – more crucially – Barthes is that, on the one hand, several great literary minds have reached similar conclusions about photography, which is perhaps comforting; while on the other, the discursive spaces where these conclusions were uttered and received have shifted and, to put it bluntly, moved away from the periphery and closer to the centres of academic, economic and/or institutional power.

To take another, symmetrical, example, a mere chronological history of the photographically illustrated book might consider that Hawthorne's *Marble Faun*, or even for that matter *The Pencil of Nature*, belong squarely in the same genre as Nan Goldin's *Ballad of Sexual Dependency* or Hervé Guibert's *Suzanne et Louise*, the differences being primarily technical or stylistic. In contrast, a more sociological (or 'archaeological' in Foucault's sense) approach would point out the great socio-cultural gap between a publisher such as Tauchnitz in 1860, targeting primarily the elite tourist market, and the Gallimard

89 Hervé Guibert, *Les lettres de Mathieu*, 1980s, gelatin silver print.

house, France's best established and most respected literary publisher since the 1930s, which in admitting Guibert and several other photo-writers into its exclusive 'white collection' has indeed crossed a threshold. Finally, to recognize that Bayard's eerie self-portraits are the first photographic fictions (or among the first) is to recognize the obvious, but to deduce that they are essentially similar to Cindy Sherman's costumed impersonations would be ahistorical (in spite of Sherman's and Bayard's shared reluctance to public speech, which reminds us of a general, perhaps even constitutional, defiance of photographers towards language). Bayard's images were, in part, playful protests against institutional injustice and went largely unheeded, whereas Sherman's *Untitled Film Stills* (which the photographer has never considered self-

portraits) issued from a highly educated and concerted artistic project and quickly earned her major institutional recognition. In photography as in other domains of culture, a history of ideas and a history of practices must always work hand in hand.

These remarks do not, however, lead to a wholly sceptical conclusion as far as the larger 'idea of photography' is concerned: there are indeed, in my view, enough hints to suggest that the accumulated record of 170 years of photographic and literary practices points in certain directions and bears witness to certain changes. First of all, as I have argued in several parts of this book, a pattern of evolution is better discerned if one considers the two mediums in solidarity rather than in opposition. In other words, one better understands what appears as a pattern of increasing literary sympathy for photography (and, conversely, a greater literary sensibility of photography) if one considers that the two mediums grew not in isolation or succession – photography following literature as a distant and younger relative – but in the same large historical period, broadly identified as modern, driven by the same general Romantic aspiration to the emancipation of individual consciousness. Social, educational or utilitarian usages of photography – or for that matter of literature – have not disappeared in this process; but what the success of sophisticated photo-literary experiments since the 1970s demonstrates is the coming of age of a hybrid 'medium of expression' (perhaps to be regarded as only a branch of the larger realm loosely called multi-media) where neither photography nor literature is clearly the parent figure. Furthermore, the mere notion of 'expression' no more suffices to summarize the second age of photography than that of 'representation' does its first age. As we have seen, the theatrical or performative components so prominent in post-1970 photography (and their inclusion in photo-literary projects) have tended to invalidate the earlier, Stieglitzian model of medium autonomy and expressiveness and the regime of photographic eloquence that supported it. It is tempting here to modify the terms, and to suggest that behind or beyond the demise of a regime of (truthful) representation and its apparent replacement by a quest for self-expression lies a more fundamental shift. This shift, arguably, has led photography (and literature) from a metaphysics of presence, to use Jacques Derrida's

expression, to a poetics of difference or *écart*.[4] That is, to a pragmatics of photographic *absence* from the world, and an ethics of photographic abstention – an unwillingness to restore the former (illusory) photographic will to order the world. To put the matter in the Peircian paradigm often used about it, photography would thus have moved from an age of the icon (or resemblance to an object fantasized as present) to an age of the index (or trace of an object observed as absent); or, again, from an art of light to an art of the shadow.[5]

Once more, here one must use caution. What Benjamin called the 'optical unconscious' was well known and commented on by nineteenth-century photographers and critics, beginning with Talbot himself, who generally produced advanced reflections on the productive absences of photography. The fact that a photographer is not usually aware of every detail his shot will reveal upon observation, or the lessons about the world and its way of looking that we learn from photographs (as in the classic case of the galloping horse), could be considered two examples. Indeed, the discovery of this visual unconscious largely predates photography, as Jonathan Crary has shown. Nonetheless, it would be difficult to deny that in the first age of photography, roughly speaking the nineteenth century, its 'idea' or its social discourse was permeated by the powerful fantasy of a newly available presence of the world, superlatively expressed by Oliver W. Holmes in his dreams of disembodied armchair travel among a vast stereoscopic 'bank of Nature' (even though the same Holmes also brilliantly elaborated on the photograph as an image of absence). This metaphysics of presence has not deserted our routine uses of photography (or television), as shown by the continual argument of football buffs in favour of video refereeing (the counter-argument being less of the nature of a contestation of photographic evidence than of an ideological line of reasoning on football as a 'human' game).

Certainly, however, the pursuit of absence has been an overwhelming trend in creative photography of the post-1970 period (and a very discernible one well before that date), while photography has also accompanied conceptual practices concerned with the disappearance of the work of art, as in land art. The same trend has been a major factor in its appeal to writers of the same period. These writers have themselves

oscillated, as in the paradigm example of Jean Baudrillard, between the 'literary' deploration of a 'desert' world and the recourse to photography as a medium, not for the restoration of presence, but for the recording of the postmodern subject's traces – often in a very intimate space, and often also in a theatre of death.[6] As such Hippolyte Bayard's bittersweet self-portraits and Hervé Guibert's terribly ordinary, untheatrical images of (his) interiors and private circumstances must be regarded, despite their superficial resemblance as 'self-expression', as absolutely antinomic. Whereas the inventor was playing dead to prove the reality of his invention and remind authorities of his angry presence, his distant successor was playing photographer to produce an advance record of his future, silent, absence. This comparison alone cannot bear the burden of the complex history which this book proposed to sketch, be it only because the mourning mode does not exhaust a contemporary scene that also manages, as with Cindy Sherman or Martin Parr, to look smilingly on our cravings for life and presence. It may, however, serve as a short illustration of the shift I have attempted to outline in photography's relationship to literature and, by the same token, the world.

References

Introduction

1 See, for example, Eduardo Cadava, *Words of Light: Theses on the Photography of History*, 2nd edn (Princeton, NJ, 1998).

2 As illustrated most recently by a large conference on the subject held in Cerisy, France, in 2007 (see Jean-Pierre Montier et al., *Littérature et photographie*, Rennes, 2008); however, photography and literature cannot be considered a new topic (see for instance the proceedings of a 1999 symposium on the subject at the University of Kent, published by Stephen Bann and Emmanuel Hermange in *Journal of European Studies*, XXX/117, March, 2000). Paul Edwards, *Soleil noir: Photographie et littérature des origines au surréalisme* (Rennes, 2008).

3 See especially Philippe Hamon, *Imageries, littérature et image au XIXe siècle* (Paris, 2001).

4 See W.J.T. Mitchell, *Iconology: Image, Text, Ideology* (Chicago, IL, 1986).

5 Jane Rabb, *Literature and Photography, Interactions 1840–1990* (Albuquerque, NM, 1995).

6 See Michel Foucault, *The Order of Things: An Archaeology of the Human Science* [French original 1966] (New York, 1970); Jean-Luc Nancy and Philippe Lacoue-Labarthe, *The Literary Absolute: The Theory of Literature in German Romanticism* [French original 1980] (Albany, NY, 1988).

7 Meyer H. Abrams, *The Mirror and the Lamp: Romantic Theory and the Critical Tradition* (Oxford, 1953).

8 See especially Pierre Bourdieu, *The Rules of Art, Genesis and Structure of the Literary Field* [French original 1992] (Stanford, CA, 1996).

9 Marsha Bryant, ed., *Photo-Textualities: Reading Photographs and Literature* (Newark, NJ, 1996).

one: Writing the Invention of Photography

1 Edgar Allan Poe, 'The Daguerreotype' [1840], in Alan Trachtenberg, ed., *Classic Essays on Photography* (New Haven, CT, 1980), p. 37.

2 Daniel J. Boorstin, *The Image: A Guide to Pseudo-Events* (New York, 1961); Régis Debray, *Vie et mort de l'image* (Paris, 1995).

3 Larry Schaaf, *Out of the Shadows: Herschel, Talbot, and the Invention of Photography* (New Haven, CT and London), 1992, p. 62; François Brunet, *La Naissance de l'idée de photographie* (Paris, 2000), pp. 74–9.

4 Even when images 'resisted' the printed page. Nancy Armstrong, *Scenes in a Library: Reading the Photograph in the Book* (Cambridge, MA, 1998), p. 3.

5 On this complex episode see the classic narrative by Beaumont Newhall, *Latent Image: The Discovery of Photography* (New York, 1966), as well as Anne McCauley, 'François Arago and the Politics of the French Invention of Photography', in Daniel P. Younger, ed., *Multiple Views: Logan Grant Essays on Photography 1983–89* (Albuquerque, NM, 1991), pp. 43–70, and Brunet, *La Naissance*, pp. 57–116.

6 Letter to Isidore Niépce, 28 April 1838, quoted in Brunet, *La Naissance*, p. 72.

7 François Arago in *Comptes rendus hebdomadaires des séances de l'Académie des Sciences*, IX (1839/2), p. 250.

8 Schaaf, *Out of the Shadows*, pp. 55–61.

9 Quoted and discussed by Paul-Louis Roubert, 'Jules Janin et le daguerréotype entre l'histoire et la réalité', in Danièle Méaux, ed., *Photographie et Romanesque, Études romanesques*, X (Caen, 2006), pp. 25–37.

10 See Roland Recht, *La Lettre de Humboldt* (Paris, 1989), pp. 10–11, which reproduces von Humboldt's letter in full (in French).

11 See Jonathan Crary, *Techniques of the Observer: On Vision and Modernity in the Nineteenth Century* (Cambridge and London, 1990).

12 This document was first noticed and commented on by Robert Taft in his *Photography and the American Scene: A Social History 1839–1889* [1938] (New York, 1964), pp. 8–12.

13 Népomucène Lemercier, 'Sur la découverte de l'ingénieux peintre du Diorama, exposé préliminaire suivi du poème "Lampélie et Daguerre"', *Institut Royal de France, Séance publique des cinq Académies du 2 mai 1839* (Paris, 1839), pp. 21–37.

14 See Eric Michaud, 'Daguerre, un Prométhée chrétien', *Études Photographiques*, II (May 1997), pp. 44–59.

15 Walter Benjamin, 'A Short History of Photography', in Trachtenberg, ed., *Classic Essays*, p. 201.

16 Tannegui Duchâtel, 'Exposé des motifs', in Louis-J.-M. Daguerre, *Historique et description des procédés du Daguerréotype et du Diorama* (Paris, 1839), p. 2.

17 Brunet, *La Naissance*, pp. 89–91, 111–16; Recht, *La Lettre de Humboldt*, pp. 134–5.

18 See Geoffrey Batchen, *Burning with Desire: The Conception of Photography* (Cambridge, MA, 1997).

19 The following section summarizes my essay 'Inventing the literary prehistory of photography: from François Arago to Helmut Gernsheim', forthcoming in Julian Luxford and Alexander Marr, eds *Literature and Photography: New Perspectives* (St Andrews, 2009). The quotes are from the text known as Arago's speech to the Chamber of Deputies, which was published in Daguerre's manual (*Historique*, see note 16 above). See p. 11 for the quote on the dream. A slightly different version of Arago's report appears in

English translation, in an abridged form, in Trachtenberg, ed., *Classic Essays*, pp. 15–25.

20 Held in the Daguerre File From the Gabriel Cromer Collection at the Société Française de Photographie, where a heliographic reproduction of this portrait by Charles Niépce is also found.

21 Most recently by Italo Zannier, *Il Sogno della Fotografia* (Collana, 2006).

22 Arago, in Daguerre, *Historique*, p. 11.

23 This connection was first publicized in a French photographic treatise of 1862, and much exploited since; see Brunet, 'Inventing the literary prehistory'.

24 Edgar Allan Poe made this connection explicitly in his 'The Thousand and Second Tale of Scheherazade' (1845); Oliver W. Holmes picked it up in his 1859 article on stereography.

25 Helmut Gernsheim, *The Origins of Photography* (London, 1982), p. 6; see also Josef-Maria Eder, *The History of Photography* [German original 1932, trans. 1945] (New York, 1978). In the recent period, see the anthologies edited by Wolfgang Baier, *Quellendarstellungen zur Geschichte der Fotografie* (Munich, 1977), and Robert A. Sobieszek, *The Prehistory of Photography: Original Anthology* (New York, 1979).

26 Arago, in Trachtenberg, ed., *Classic Essays*, p. 22.

27 Edgar Allan Poe, 'The Daguerreotype', in Trachtenberg, ed., *Classic Essays*, p. 38.

28 See Brunet, *La Naissance*, pp. 113–15.

29 Arago, in Daguerre, *Historique*, p. 13.

30 Francis Wey, 'Comment le soleil est devenu peintre, Histoire du daguerréotype et de la photographie', *Musée des Familles*, xx (1853), pp. 257–65, 289–300; Louis Figuier, *La photographie, Exposition et histoire des principales découvertes scientifiques moderns* (Paris, 1851), pp. 1–72; see André Gunthert, 'L'inventeur inconnu, Louis Figuier et la constitution de l'histoire de la photographie française', *Études Photographiques*, xvi (May 2005), pp. 7–16.

31 Arago in Trachtenberg, ed., *Classic Essays*, p. 17.

32 Schaaf, *Out of the Shadows*, p. 83.

33 Larry Schaaf, *Records of the Dawn of Photography: Talbot's Notebooks P & Q* (Cambridge and Melbourne, 1996), p. xxvi.

34 Larry Schaaf, *The Photographic Art of William Henry Fox Talbot* (Princeton, NJ, 2000), p. 78.

35 Reprinted in Beaumont Newhall, *Photography: Essays and Images* (New York, 1980), pp. 23–31.

36 Talbot, 'Some Account of the Art of Photogenic Drawing . . .', in Newhall, *Essays and Images*, p. 25.

37 Both texts are quoted and commented on by Graham Smith in *Light that Dances in the Mind: Photographs and Memory in the Writings of E. M. Forster and his Contemporaries* (Oxford, 2007), pp. 158–160.

38 Adolfo Bioy Casares, *The Invention of Morel* [Spanish original 1940] (New York, 1964); G. Davenport, 'The Invention of Photography in Toledo [1976/1979]', in Jane Rabb, ed., *The Short Story and Photography 1880s–1990s: A Critical Anthology* (Albuquerque, NM, 1998), pp. 223–33.

39 Odette Joyeux, *Niépce: Le Troisième Œil* (Paris, 1989); see Brunet, 'Inventing the literary prehistory'.

40 Vachel Lindsay, *The Art of the Moving Picture* (New York, 1922); see the critical edition and commentary by Marc Chénetier, *De la caverne à la pyramide (Écrits sur le cinéma 1914–1925)*, (Paris, 2001). The hieroglyphic argument was later developed by the Frankfurt School: see Miriam Hansen, 'Mass Culture as Hieroglyphic Writing: Adorno, Derrida, Kracauer', *New German Critique*, LVI (Spring/Summer, 1992), pp. 43–73.

two: Photography and the Book

1 James Agee and Walker Evans, *Let Us Now Praise Famous Men* [1941] (Boston, 2001), p. 13.

2 See Richard Bolton, ed., *The Contest of Meaning: Critical Histories of Photography* (Cambridge, MA, 1989), especially Douglas Crimp, 'The Museum's Old / The Library's New Subject' [1984], pp. 3–13.

3 Helmut Gernsheim, *Incunabula of British Photographic Literature: A Bibliography of British Photographic Literature 1839–75 and British Books Illustrated with Original Photographs* (Berkeley, CA, 1984); Lucien Goldschmidt and Weston J. Naef, *The Truthful Lens: A Survey of the Photographically Illustrated Book, 1844–1914* (New York, 1980).

4 See Martin Parr and Gerry Badger, *The Photobook: A History*, vols I and II (New York, 2004, 2006); also Susan Sontag, *On Photography* (New York, 1977), p. 4.

5 Among many useful studies on that subject, see especially Marsha Bryant, ed., *Photo-Textualities: Reading Photographs and Literature* (Newark, NJ, 1996).

6 See Larry Schaaf, *The Photographic Art of William Henry Fox Talbot* (Princeton, NJ, 2000), pp. 28, 36, etc. Talbot was very explicit about this in his 1839 memoir ('Some Account of the Art', in Beaumont Newhall, *Photography: Essays and Images* [New York, 1980], p. 28).

7 The actual number of copies produced is not known with certainty and varies from one instalment to the next; not more than 300 copies of the first one were produced. The price of instalments ranged from 7 to 21 shillings, making the combined value of the series about £3, to be compared to the average monthly salary of about £4 for a factory worker. See Larry Schaaf, 'Brief Historical Sketch', in H. Fox Talbot's *The Pencil of Nature*, Anniversary Facsimile (New York, 1989).

8 See William Ivins, *Prints and Visual Communication* (London, 1953); Estelle Jussim, *Visual Communication and the Graphic Arts: Photographic Technologies in the Nineteenth Century* (New York,

1974); *Études Photographiques*, xx (June 2007), *La trame des images, Histoire de l'illustration photographique*, especially the articles by Stephen Bann, Pierre-Lin René, and Therry Gervais.

9 See for instance Mike Weaver, *The Photographic Art: Pictorial Traditions in Britain and America* (New York, 1986).

10 Hubertus von Amelunxen, *Die Aufgehobene Zeit. Die Erfindung der Photographie durch William Henry Fox Talbot* (Berlin, 1989), p. 25. See also François Brunet, *La Naissance de l'idée de photographie* (Paris, 2000), pp. 117–56.

11 Several commentators besides von Amelunxen and myself have defended this view, especially Nancy Armstrong in *Scenes in a Library: Reading the Photograph in the Book* (Cambridge, MA, 1998), and most recently Roberto Signorini, *Alle origini del fotografico, Lettura di The Pencil of Nature (1844–46) di William Henry Fox Talbot* (Bologna, 2007).

12 On 'The Haystack', see, most recently, Jean-Christophe Bailly, *L'Instant et son ombre* (Paris, 2008).

13 Charles Darwin, *The Expression of Emotions in Man and Animals* (London, 1872), p. vi.

14 Isabelle Jammes, *Blanquart-Evrard et les origines de l'édition photographique française* (Geneva and Paris, 1981).

15 Claire Bustarret, 'Vulgariser la Civilisation: science et fiction d'après photographie', in Stéphane Michaud et al., eds, *Usages de l'image au xixe siècle* (Paris, 1992), pp. 138–9.

16 See Nancy Armstrong, *Scenes in a Library: Reading the Photograph in the Book* (Cambridge, MA, 1998), pp. 284ff.

17 André Jammes and Eugenia Parry Janis, *The Art of French Calotype, with a Critical Dictionary of Photographers, 1845–1870* (Princeton, NJ, 1983); Anne de Mondenard, *La Mission Héliographique: Cinq photographes parcourent la France en 1851* (Paris, 2002).

18 Weston J. Naef and James N. Wood, *Era of Exploration, the Rise of Landscape Photography in the American West* (New York, 1976); François Brunet and Bronwyn Griffith, eds, *Images of the West, Survey Photography in the American West 1860–80* (Chicago, IL, 2007).

19 Martha Sandweiss, *Print the Legend: Photography and the American West* (New Haven, CT, 2002).

20 See for instance Josiah D. Whitney, *The Yosemite Book* (New York, 1868).

21 Especially in his privately published album, *The Three Lakes and How They Were Named*, 1870. See Alan Trachtenberg, 'Naming the View', in *Reading American Photographs: Images as History, Mathew Brady to Walker Evans* (New York, 1989), pp. 119–27. Another literary treatment of O'Sullivan's survey photographs – possibly the work of C. King – shows through a series of unofficial, often witty captions given them in a few archival collections. See François Brunet, 'Revisiting the enigmas of Timothy H. O' Sullivan, Notes on the William Ashburner collection of King Survey photographs at the Bancroft Library', *History of Photography*, xxxi/2 (Summer 2007), pp. 97–133.

22 Robin Kelsey, *Archive Style: Photographs and Illustrations for us Surveys, 1850–1890* (Berkeley, CA, 2007).

23 See Maren Stange, *Symbols of Ideal Life: Social Documentary Photography in America, 1890–1950* (New York, 1992), pp. 47–87.

24 See Mick Gidley, *Edward S. Curtis and the North American Indian, Incorporated* (Cambridge, 1998).

25 See Olivier Lugon, *Le Style documentaire d'August Sander à Walker Evans* (Paris, 2002).

26 Michael Jennings, 'Agriculture, Industry, and the Birth of the Photo-Essay in the Late Weimar Republic', *October*, xciii (Summer 2000), pp. 23–56.

27 Ibid., p. 23.

28 See William Stott, *Documentary Expression in Thirties America* (New York, 1973); Stange, *Symbols of Ideal Life*.

29 Peter Cosgrove, 'Snapshots of the Absolute: Mediamachia in *Let Us Now Praise Famous Men*', *American Literature*, lxvii/2 (1995), pp. 329–57. In his chapter on the photographic essay in *Picture Theory* (Chicago, IL, 1994), W.J.T. Mitchell treats this agonistic relationship of pictures and text as a paradigm for the genre (pp. 285–300).

30 William Klein, *Life Is Good & Good for You in New York: Trance Witness Revels* (Paris, 1955).

three: Literary Discoveries of Photography

1 Betty Miller, ed., *Elizabeth Barrett to Miss Mitford: The Unpublished Letters of Elizabeth Barrett Browning to Mary Russell Mitford* (New Haven, CT, 1954), pp. 208–9.

2 Alan Trachtenberg, 'Introduction', in *Classic Essays on Photography*, ed. Alan Trachtenberg (New Haven, CT, 1980), p. vii; other anthologies published in the same period include: Beaumont Newhall, ed., *Photography : Essays and Images* (New York, 1980); Vicki Goldberg, ed., *Photography in Print: Writings from 1816 to the Present* (New York, 1981); see also the generous selection of quotations provided as an appendix to Susan Sontag's *On Photography* (New York, 1977).

3 Roland Barthes, *La Chambre Claire, Note sur la Photographie* (Paris, 1980); English translation, *Camera Lucida, Reflections on Photography* (New York, 1981). Other influential essays of the period include Susan Sontag's *On Photography* (translated into French in 1979) and John Berger, *About Looking* (New York, 1980).

4 Barthes, *Camera Lucida*, p. 95.

5 See, on the connection to the photo-essay, W.J.T. Mitchell, *Picture Theory* (Chicago, IL, 1994), pp. 301–22. See also Barthes' earlier illustrated autobiography, *Barthes by Barthes* [French original 1975] (New York, 1977), and Philippe Ortel's remarks in Danièle Méaux, *Photographie et Romanesque, Études romanesques*, x (Caen, 2006), p. 219; also below, chapter Five, for the connection to autofiction.

6 See Trachtenberg's remarks in his Introduction to *Classic Essays*, pp. vii–xiii; Jan Baetens rightly stresses the influence of writers on

critical paradigms in photography, 'Conceptual Limitations of our Reflection on Photography', in James Elkins, ed., *Photography Theory* (New York, 2007), p. 57. In the short bibliography appended to *Camera Lucida* Barthes only included Paul Valéry and Susan Sontag from this list; the book was dedicated to Sartre's *L'Imaginaire* (1940).

7 On Balzac, who expressed enthusiasm in two letters in 1842, see Philippe Ortel, *La Littérature à l'ère de la photographie, Enquête sur une révolution invisible* (Nîmes, 2002), pp. 201–3; the writer did, however, include an echo of his theory of spectra, later popularized by Nadar, in his novel *Le Cousin Pons* (1847); on Dickens, see Claude Baillargeon, *Dickensian London and the Photographic Imagination* (Rochester, MI, 2003), p. 3; on Tolstoy's (apparently benign) silence on photography, Thomas Seifrid, 'Gazing on Life's Page: Perspectival Vision in Tolstoy', in *PMLA*, CXIII/3 (May 1998), p. 443.

8 See Trachtenberg, *Classic Essays*, p. 37. These articles were first identified as being Poe's by Clarence S. Brigham in *Edgar Allan Poe's Contributions to Alexander's Weekly Messenger* (Worcester, MA, 1943), pp. 20–22, 82.

9 As founder of the magazine *Stylus* and editor of several others, Poe had first-hand experience of illustration; he was actively involved in the production of his own portraits and well aware of the sitters input in his/her image; see Kevin J. Hayes, 'Poe, the Daguerreotype, and the Autobiographical Act', in *Biography*, XXV/3 (Summer 2002), pp. 477–92.

10 See François Brunet, 'Poe à la croisée des chemins: réalisme et scepticisme', in *Revue Française d'Études Américaines*, LXXI (January 1997), pp. 44–50.

11 Especially 'Nature' (1836), which exhorts the reader to see truly and in one passage describes the delights of looking in a camera obscura, and 'The American Scholar' (1837), where one of the tasks ascribed to the ideal scholar is observation; see François Brunet, *La Naissance de l'idée de photographie* (Paris, 2000), pp. 198–209.

12 William Gilman et al., eds, *The Journals and Miscellaneous Notebooks of Ralph Waldo Emerson* (1970), VIII, pp. 115–16. See about all this in Brunet, *La Naissance*, pp. 198–209; Sean Ross Meehan, 'Emerson's Photographic Thinking', in *Arizona Quarterly: A Journal of American Literature, Culture, and Theory*, LXII/2 (Summer 2006), pp. 27–58.

13 One of the best analyses of this romance, which also draws a striking correlation between it and Postmodern rituals of portraying (fictional) death, is Cathy N. Davidson, 'Photographs of the Dead: Sherman, Daguerre, Hawthorne', in *South Atlantic Quarterly*, LXXXIX/4 (Fall 1990), pp. 667–701. See also Alan Trachtenberg's beautiful essay, 'Seeing and Believing: Hawthorne's Reflections on the Daguerreotype in "The House of the Seven Gables"', in *American Literary History*, IX/3 (Autumn 1997), pp. 460–81.

14 In a passage of the 1857 journals we read about the heterogeneity of man's conscience:

And I learn from the photograph & daguerre men, that almost all faces & forms that come to their shops to be copied, are irregular & unsymmetrical, have one eye blue & one gray, that the nose is not straight, & one shoulder is higher than the other. The man is physically as well as metaphysically a thing of shreds & patches. (*The Journals*, vol. XIV, p. 126)

In the essay 'Beauty' (1860), the same passage is rephrased: 'Portrait painters say that most faces and forms are irregular and unsymmetrical; have one eye blue, and one gray . . .'

15 See F. Brunet, '"Quelque chose de plus": la photographie comme limite du champ esthétique (Ruskin, Emerson, Proust)', in Brunet et al., *Effets de cadre, De la limite en art* (Saint-Denis, 2003), pp. 29–52.

16 The most detailed account is in Aaron Scharf, *Art and Photography* (Baltimore, MD, 1969), pp. 95–102. A substantial selection of quotes appears in Jane Rabb, *Literature and Photography: Interactions, 1840–1990* (Albuquerque, NM, 1995), pp. 110–15. See also the discussion in Brunet, '"Quelque chose de plus"'.

17 English translation of this section in Trachtenberg, *Classic Essays*, pp. 83–90.

18 See Philippe Ortel, *La Littérature à l'ère de la photographie, Enquête sur une revolution invisible* (Nîmes, 2002), pp. 175ff; Jérôme Thélot, *Les inventions littéraires de la photographie* (Paris, 2004), p. 73; Paul-Louis Roubert, *L'image sans qualités, Les beaux-arts et la critique à l'épreuve de la photographie 1839–1859* (Paris, 2006), especially pp. 143–7; on Hippolyte Taine's quasi-experimental exploration of Flaubert's photographic brain, see Bernd Stiegler, '"Mouches volantes" et "papillons noirs", Hallucination et imagination littéraire, note sur Hippolyte Taine et Gustave Flaubert', in Méaux, *Photographie et Romanesque*, pp. 9–48; on Gautier, Bernd Stiegler, 'La surface du monde: note sur Théophile Gautier', *Romantisme*, CV (1999/3), pp. 91–5.

19 Even though the ten artists, as true Realists, had copied the scene with every possible accurateness; see Ortel, *La Littérature*, pp. 188–9. Champfleury would follow in 1863 with a dark humour tale, 'The Legend of the Daguerreotype', staging a newly established operator who, after countless trials at producing, with the help of many dangerous chemicals, a satisfactory portrait of a naive provincial sitter, finally brought out a likeness on the plate, only to discover that the model had been eliminated, eaten away by his chemicals, leaving only his voice to accuse the murderous daguerreotypist; as Jérôme Thélot notes, this caricature was, like the 1857 parable, targeted equally at the legend or ideology of photographic accuracy and at its more extreme or naive detractors. See Ortel, *La Littérature*, pp. 122–3; Thélot, *Inventions*, pp. 71–88; Rabb, *Literature and Photography*, pp. 10–14.

20 See Thélot, *Inventions*, pp. 40–52, whose hypothesis is based on the earlier comments of Eric Darragon.

21 Elizabeth Eastlake, 'Photography' [1857], in Beaumont Newhall, *Photography: Essays and Images*, pp. 81–96 (quote on p. 94). The

phrase was borrowed by Newhall as the title of his *History of Photography*'s chapter on early documentary and illustrative projects.

22 See my preface and notes to the French translation of this essay in *Études Photographiques*, XIV (January 2004), pp. 105–7.

23 O. W. Holmes, 'The Stereoscope and the Stereograph' [1859], in Newhall, *Photography: Essays and Images*, p. 53.

24 O. W. Holmes, 'Sun Painting and Sun Sculpture', in *The Atlantic Monthly*, VIII (1861), p. 13.

25 Holmes, 'The Stereoscope and the Stereograph', p. 59. See Miles Orvell, 'Virtual Culture and the Logic of American Technology', *Revue Française d'Études Américaines*, LXXVI (March 1998), pp. 12–13.

26 Holmes, 'Sun Painting and Sun Sculpture', pp. 21–2. Earlier in the same text, Holmes wrote:

> no picture produces an impression on the imagination to compare with a photographic transcript of the home of our childhood . . . The very point which the artist omits, in his effort to produce general effect, may be exactly the one that individualizes the place most strongly to our memory.

In a picture of his birthplace, Holmes singles out 'a slender, dry, leafless stalk' which 'an artist would hardly have noticed; but to us it marks the stem of the *honeysuckle vine*, which we remember, with its pink and white heavy-scented blossoms, as long as we remember the stars in heaven' (14); compare Barthes' description of a house in Granada, *Camera Lucida*, p. 38–9.

27 The best surveys are those of Jane Rabb (*Literature and Photography* and *The Short Story and Photography*), on which this section largely relies.

28 While Jude burns his own portrait out of spite at his lost wife's having sold it at auction, the poem's speaker claims that the deed 'was done in a casual clearance of life's arrears yet feels as if I had put her to death that night!'; see Julie Grossmann, 'Hardy's "Tess" and "The Photograph": Images to die for – Thomas Hardy', in *Criticism*, XXXV (Fall 1993), pp. 609–31.

29 See Méaux, *Photographie et Romanesque*, pp. 6–8.

30 On photography and the 1900 literary landscape, see Graham Smith, *Light that Dances in the Mind, Photographs and Memory in the Writings of E. M. Forster and his Contemporaries* (Oxford, 2007), especially pp. 33–45 on the 'snapshot method'; on philosophical uses of photography in this period, Brunet, *La Naissance*, pp. 269–305.

31 Smith, *Light that Dances in the Mind*, pp. 129–54, 167–75.

32 See Jean-François Chevrier, *Proust et la photographie* (Paris, 1982); Brassaï, *Proust in the Power of Photography* [French original 1997] (Chicago, IL, 2001); Brunet, '"Quelque chose de plus"'.

33 This story serves as emblem for Miles Orvell's history of authenticity in American culture, *The Real Thing: Imitation and Authenticity in American Culture, 1880–1940* (Chapel Hill, NC, 1989). On James's complex attitude towards photography, see chapter Five .

34 Translation in Trachtenberg, *Classic Essays*, p. 195.

35 C. Phillips, *Photography in the Modern Era: European Documents and Critical Writings, 1913–1940* (New York, 1989), p. xii.

36 See, for instance, Aragon's comments on the photomontages of John Heartfield and revolutionary beauty in Phillips, *Photography in the Modern Era*, pp. 60–67, and Pablo Neruda's poem, 'Tina Modotti is Dead' (1942), in Rabb, *Literature and Photography*, pp. 327–29.

37 Gisèle Freund, *La photographie en France au dix-neuvieme siecle: essai de sociologie et desthétique* (Paris, 1936), which was the basis for her later, popular essay, *Photography and Society* [French original 1974] (Boston, MA, 1980).

38 See Rabb, *The Short Story and Photography*. Among numerous American short stories of the period with a photographic theme one may cite Raymond Carver's 'Viewfinder' (1981) and Cynthia Ozick's 'Shots' (1982).

39 See Jean Arrouye, 'Du voir au dire: *Noces* de Jean Giono', in Méaux, *Photographie et Romanesque*, pp. 143–56.

40 See especially P. Modiano, *Livret de famille* (1977); W. G. Sebald, *Vertigo* (1990).

41 In *Camera Lucida* Barthes consistently used the word 'realism' in a philosophical rather than a literary sense, that is, in the sense of the photograph constituting evidence of (a) reality.

42 Marshall McLuhan, *Understanding Media: The Extensions of Man* [1964], critical edn by W. Terrence Gordon (Corte Madera, CA, 2003), p. 267. For a reappraisal of Boorstin's critique of the image, see Stephen J. Whitfield, 'The Image: The Lost World of Daniel Boorstin', *Reviews in American History*, XIX/2 (June 1991), pp. 302–12.

43 Sontag, *On Photography*, p. 29.

four: The Literature of Photography

1 Edward Weston, *The Daybooks of Edward Weston, Two volumes in one*, ed. Nancy Newhall [1966] (New York, 1990), vol. 2, California, p. 24.

2 Vicki Goldberg, ed., *Photography in Print: Writings from 1816 to the Present* (New York, 1981), p. 148.

3 In O'Sullivan's case, the existence of an anonymous but well-informed account of his activities as a survey photographer in the American West, complete with actual quotes of the otherwise unnamed artist, published in *Harper's Monthly* in 1869, further compounds our understanding of his public persona at the time. See Robin Kelsey, *Archive Style: Photographs and Illustrations for US Surveys, 1850–1890* (Berkeley, CA, 2007), pp. 122–8.

4 See the remarkable analysis by Philippe Hamon, 'Pierrot photographe', *Romantisme*, CV/3 (1999), pp. 35–44.

5 See François Brunet, '"Picture Maker of the Old West": W. H. Jackson and the Birth of Photographic Archives in the US', *Prospects*, XIX (1994), pp. 161–87.

6 Helmut Bossert and Heinrich Guttmann, *Aus der Fruhzeit der Photographie 1840–70* (Frankfurt am Main, 1930).

7 In France, Capa's life story has inspired the popular series of adventures of 'Boro the photographer' by Hervé Hamon and Patrick Rotman.

8 One important example is the long essay in defence of Pictorialism by Marcel Proust's friend Robert de la Sizeranne, 'La photographie est-elle un art?', *Revue des Deux Mondes*, 4th period, CXLIV (November–December 1897), pp. 564–95.

9 See Jonathan Green, *Camera Work: A Critical Anthology* (Washington, DC, 1973).

10 See Sarah E. Greenough and Juan Hamilton, *Alfred Stieglitz: Photographs and Writings* (Washington, DC, 1983).

11 Waldo Frank et al., *America and Alfred Stieglitz: A Collective Portrait* (New York, 1934); Richard F. Thomas, *Literary Admirers of Alfred Stieglitz* (Carbondale, IL, 1983).

12 Alan Sekula, 'On the Invention of Photographic Meaning' [1975], in Goldberg, *Photography in Print*, pp. 452–73. By contrast, both Robert Taft's and Georges Potonniée's histories of photography upheld a technical and social framework. Constructing photographic history as a history of practices rather than as a history of images, they gave little consideration to the semantic or stylistic commentary of individual photographs.

13 Beamont Newhall, foreword to Weston, *Daybooks of Edward Weston*, p. xiii. Also see Sontag, *On Photography*, pp. 96–7.

14 A classic formulation for this reading is Christopher Phillips, 'The Judgment Seat of Photography' [1982], in *The Contest of Meaning: Critical Histories of Photography*, ed. Richard Bolton (Cambridge, 1989), pp. 15–46; see also the other essays in this collection.

15 Clément Chéroux, 'Les récréations photographiques, un répertoire de formes pour les avant-gardes', *Études photographiques*, V (1998), pp. 73–96.

16 Michel Foucault, 'La peinture photogénique' [1975], in *Dits et écrits*, vol. II (Paris, 1994), pp. 708–15.

17 John Harvey, *Photography and Spirit* (London, 2007); Clément Chéroux, ed., *The Perfect Medium: Photography and the Occult* (New Haven, CT, 2005).

18 Miles Orvell, *American Photography* (Oxford, 2003), p. 163.

19 A. D. Coleman, 'The Directorial Mode: Notes toward a Definition' [1976], in *Light Readings: A Photography Critic's Writings, 1968–1978* (New York, 1979), pp. 246–57, and in Goldberg, *Photography in Print*, pp. 480–91. Jean-François Lyotard's *The Postmodern Condition: A Report on Knowledge*, trans. Geoff Bennington and Brian Massumi (Manchester, 1984), foregrounded the fragmented, personal, anti-authoritarian micro-narrative as the defining genre of postmodernity.

20 See Douglas Crimp, 'The Museum's Old / The Library's New Subject' [1984], in Bolton, ed., *The Contest of Meaning*. See also Kathleen A. Edwards, *Acting Out: Invented Melodrama in Contemporary Photography* (Seattle, OR, 2005), and Katherine A. Bussard, *So the Story Goes: Photographs by Tina Barney, Philip-Lorca diCorcia, Nan Goldin, Sally Mann, and Larry Sultan* (Chicago, 2006).

five: The Photography of Literature

1 Arthur Schopenhauer, 'Physiognomy', in *Parerga and Paralipomena* [1851], vol. II, chap. 29, sect. 377.

2 Jane Rabb, ed., *Literature and Photography, Interactions, 1840–1990* (Albuquerque, NM, 1995); Ann Wilsher, 'Photography in Literature: The First Seventy Years', *History of Photography*, II/3 (July 1978), pp. 223–54; Hubertus von Amelunxen, 'Quand le photographie se fit lectrice: le livre illustré par la photographie au xixème siècle', *Romantisme*, XV/47 (1985), pp. 85–96; Marsha Bryant, ed., *Photo-Textualities: Reading Photographs and Literature* (Newark, NJ, 1996); Jan Baetens and Hilde van Gelder, 'Petite poétique de la photographie mise en roman (1970–1990)', in Danièle Méaux, ed., *Photographie et Romanesque, Études romanesques*, X (Caen, 2006), pp. 257–72; see also the following footnotes.

3 Carol Armstrong, *Fiction in the Age of Photography: The Legacy of British Realism* (Cambridge, MA, 1999); Jennifer Green-Lewis, *Framing the Victorians: Photography and the Culture of Realism* (Ithaca, NY, 1997); see also Helen Groth, *Victorian Photography and Literary Nostalgia* (New York, 2003).

4 Carol Shloss, *In Visible Light: Photography and the American Writer* (New York, 1987).

5 Philippe Ortel, *La Littérature à l'ère de la photographie, Enquête sur une révolution invisible* (Nîmes, 2002), p. 248, in reference to the famous poem by Stéphane Mallarmé on 'The Tomb of Edgar Poe' (1879), written under the inspiration provided by a photograph of the Baltimore shrine.

6 Jérôme Thélot, *Les inventions littéraires de la photographie* (Paris, 2004), pp. 1–2.

7 Herman Melville, *Pierre: or, The Ambiguities*, ed. Harrison Hayford, Hershel Parker, and G. Thomas Tanselle (Evanston and Chicago, IL, 1970), p. 254; see Kevin J. Hayes, 'Poe, the Daguerreotype, and the Autobiographical Act', *Biography*, XXV/3 (Summer 2002), pp. 481.

8 John W. Blessingame, ed., *The Frederick Douglass Papers*, series 1: *Speeches, Debates, and Interviews*, vol. III: *1855–63* (New Haven, CT, 1985), p. 455.

9 Sarah Blackwood, '"The Inner Brand": Emily Dickinson, Portraiture, and the Narrative of Liberal Interiority', *Emily Dickinson Journal*, XIV/2 (Fall 2005), pp. 48–59.

10 Rabb, *Literature and Photography*, p. 110.

11 Ibid., pp. 23–4.

12 Helen Groth, 'Consigned to Sepia: Remembering Victorian Poetry', *Victorian Poetry*, XLI/4 (Winter 2003), p. 613. On French writers, see Ortel, *La Littérature*, pp. 286–91, and Yvan Leclerc, 'Portraits de Flaubert et de Maupassant en photophobes', *Romantisme*, CV/3 (1999), pp. 97–106.

13 Thélot, *Inventions*, pp. 10ff. See the exhibition catalogue by Françoise Heilbrun et al., *En collaboration avec le Soleil. Victor Hugo, photographies de l'exil* (Paris, 1998).

14 Rabb, *Literature and Photography*, p. 42, quotes extensively from Adèle Hugo's diary.

15 Jean-Pierre Montier, 'D'un palimpseste photographique dans *Les Travailleurs de la mer* de Victor Hugo', in Méaux, *Photographie et Romanesque*, p. 63.

16 Thélot, *Inventions*, p. 11.

17 Rabb, *Literature and Photography*, pp. 19ff. See Alan Trachtenberg, *Reading American Photographs: Images as History, Mathew Brady to Walker Evans* (New York, 1989), pp. 60–70; Ed Folsom, *Walt Whitman's Native Representations* (Cambridge, 1997); Miles Orvell, *The Real Thing: Imitation and Authenticity in American Culture, 1880–1940* (Chapel Hill, NC, 1989), pp. 3–28.

18 Walt Whitman, 'Visit to Plumbe's Gallery' [1846], in Rabb, *Literature and Photography*, p. 21.

19 Shelton Waldrep, *The Aesthetics of Self-invention: Oscar Wilde to David Bowie* (Minneapolis, MN, 2004).

20 Thomas Seifrid, 'Gazing on Life's Page: Perspectival Vision in Tolstoy', *PMLA*, CXIII/3 (May 1998), p. 443, who stresses both the writer's silence on photography and his 'prolific willingness to be a subject'.

21 Thélot, *Inventions*, pp. 125–59, bases this thesis on his interpretation of the poem 'The Future Phenomenon', and adds that although Mallarmé never expressed himself publicly on photography he was much attracted to photographs in his later life; among his later, anecdotal poetry gathered in 1920 as *Vers de Circonstance* are a number of verses calligraphed on the margins of photographs (collected as *Photographies*, see pp. 156–8). For a detailed commentary on the Degas photograph, which was prized by Paul Valéry, see Carol Armstrong, 'Reflections on the Mirror: Painting, Photography, and the Self-Portraits of Edgar Degas', *Representations*, XXII (Spring 1988), pp. 115ff.

22 Rabb, *Literature and Photography*, p. 93; Ortel, *La Littérature*, pp. 218–22.

23 Rabb, *Literature and Photography*, pp. 158–63.

24 Welty's late fame as a photographer began after the appearance of her *One Time, One Place: Mississippi in the Depression* (1971) and increased with her book *Photographs* (1989); she emphasized the formative role of photography for her writing in her illustrated autobiography, *One Writer's Beginnings* (1984). Géraldine Chouard notes that it took nearly half a century for her photography to be revealed to the public ('Eudora Welty's Photography or the Retina of Time', *Études Faulknériennes*, V (June 2005), pp. 19–24; see also the contributions by Hunter Cole and Jean Kempf in this collection).

25 There are others, such as, for instance, a group of American women photographers gathered by Jane Rabb in her anthology, some writers themselves and some married to writers, who devoted much of their photography to literary portraits – especially of poets, such as e. e. cummings (Marion Morehouse) and the Grove Press group (Elsa Dorfman): see Rabb, *Literature and Photography*, pp. 469–77.

26 Paul Virilio, *The Aesthetics of Disappearance* [French original 1980] (New York, 1991).

27 See Ann Wilsher, 'The Tauchnitz "Marble Faun"', *History of Photography*, IV/1 (January 1980), pp. 61–6.

28 See Nancy Armstrong, *Scenes in a Library*, pp. 281ff, 332; Groth, 'Consigned to Sepia', p. 619, comments in detail on an 1891 illustrated edition of E. Barrett Browning's *Casa Guidi Windows* by the poet and critic Agnes Mary Frances Robinson.

29 Armstrong, *Scenes in a Library*, pp. 361–421, concludes her study of Cameron's illustrations of Tennyson with the suggestion that their Victorian eccentricity echoes our own era's conversion of the photographic medium into an all-powerful industry of fantasy fulfilment (p. 421). See also Alison Chapman, 'A Poet Never Sees a Ghost: Photography and Trance in Tennyson's Enoch Arden and Julia Margaret Cameron's Photography', *Victorian Poetry*, XLI/1 (Spring 2003), pp. 47–71; and Victoria C. Olsen, *From Life: The Story of Julia Margaret Cameron and Victorian Photography* (New York, 2003).

30 On Carroll's photography, see Roger Taylor and Edward Wakeling, *Lewis Carroll, Photographer* (Princeton, NJ, 2002); Douglas Nickel, *Dreaming in Pictures: The Photography of Lewis Carroll* (New Haven, CT, 2002). Possibly it was in reference to Carroll's parable that in 1903 Charles Sanders Peirce compared the blank sheet of assertion of his existential graphs to 'a film upon which there is, as it were, an undeveloped photograph of the facts in the universe'. *Lowell Lectures of 1903*, in Charles Hartshorne and Paul Weiss, eds, *The Collected Papers of Charles Sanders Peirce* (Cambridge, MA, 1931–5), IV, §512.

31 On Carroll's derisive comments on vanity and narrow-mindedness (as opposed to Baudelaire's anger), see the 1975 analysis by Brassaï, in Rabb, *Literature and Photography*, p. 51. On the Bloomsbury group see Graham Smith, *Light that Dances in the Mind: Photographs and Memory in the Writings of E. M. Forster and his Contemporaries* (Oxford, 2007), and Maggie Humm, *Modernist Women and Visual Cultures: Virginia Woolf, Vanessa Bell, Photography, and Cinema* (New Brunswick, NJ, 2003).

32 Like other French historians, Ortel, in *La Littérature*, pp. 17–18, dates the beginnings of photo-illustration in literature to this

publication; see, for developed commentaries, Paul Edwards, 'The Photograph in Georges Rodenbach's *Bruges-la-Morte* (1892)', *Journal of European Studies*, xxx/117 (2000), pp. 71–89; and Georges Rodenbach, *Bruges-la-Morte*, ed. Jean-Pierre Bertrand and Daniel Grojnowski (Paris, 1998), especially 'Présentation', pp. 7–46 and 'Note sur les négatifs', pp. 317–19.

33 See a summary of this investigation in Rodenbach, *Bruges-la-Morte*, pp. 319ff; and a detailed survey of turn-of-the-century photo-novels in France by Paul Edwards, 'Roman 1900 et photographie (les editions Nillson/Per Lamm et Offenstadt Frères)', *Romantisme*, cv/3 (1999), pp. 133–44.

34 André Breton, *Nadja* (Paris, 1928), p. 199.

35 As early as 1924 Breton based his definition of the surrealist image on photography; see Michel Poivert, 'Politique de l'éclair. André Breton et la photographie', *Études photographiques*, vii (May 2000), pp. 52–72.

36 Quoted in Alan Trachtenberg, *Classic Essays on Photography* (New Haven, ct, 1980), p. 192.

37 Georges Potonniée, *Cent ans de photographie* (Paris, 1940), pp. 169ff.

38 Ralph Bogardus, *Pictures and Texts: Henry James, A. L. Coburn, and New Ways of Seeing in Literary Culture* (Ann Arbor, mi, 1984); Stanley Tick, 'Positives and Negatives: Henry James vs. Photography', *Nineteenth Century Studies*, vii (1993), pp. 69–101; Wendy Graham, 'Pictures for Texts', *Henry James Review*, xxiv/1 (2003), pp. 1–26; Coburn's remarks are quoted in Rabb, *Literature and Photography*, pp. 168–74. See also Baetens and Van Gelder, 'Petite poétique de la photographie', pp. 259–60.

39 Jean-François Chevrier, *Proust et la photographie* (Paris, 1982); François-Xavier Bouchart, *Proust et la figure des pays* (Paris, 1982).

40 Roland Barthes, 'The Photographic Message', in *Image–Music–Text* (New York, 1977), pp. 15–31.

41 The term was coined in 1977 by Serge Doubrovsky in reference to his own novel *Fils* (Paris, 1977) (see the back cover), and has been used extensively since then; on photography's relationship to this genre see Méaux, *Photographie et romanesque*, esp. pp. 211–330; on Barthes see chapter Three above.

42 Benoît Peeters and Marie-Françoise Plissart, *Fugues* (Paris, 1983); *Droit de regards* (Paris, 1985) (with an analysis by Jacques Derrida); *Le Mauvais Oeil* (Paris, 1986), etc.

43 See Jean Baudrillard, *Cool Memories* (1987–2005), *Sur la photographie* (1999), and the great retrospective show of his photography at the *Kassel Documenta* (2005), *La Disparition du monde*. See also Régis Debray, *L'œil naïf* (Paris, 1994).

Photographie et Romanesque, Études romanesques, x (Caen, 2006), p. 269.

2 For a larger presentation of this thesis see my *La Naissance de l'idée de photographie*.

3 Michel Foucault, 'La peinture photogénique' [1975], in *Dits et écrits*, vol. ii (Paris, 1994) pp. 708–15.

4 See the title given to a French edition of Rosalind Krauss's essays on photography, *Le Photographique, Pour une théorie des écarts* (Paris, 1990).

5 On photography's links to an art of shadows, see the influential treatise by Junichiro Tanizaki, *In Praise of Shadows* [Japanese original 1933] (New Haven, ct, 1977).

6 In 1980, the same year that Barthes in *Camera Lucida* brought to the fore the many affinities of photography and death, the Polish stage director Tadeusz Kantor displayed in *Wielopole-Wielopole* a photographer widow armed with a machine-gun concealed in a daguerreotype apparatus, shooting random victims in an allegory of the angel of death. See also Susan Sontag, *On Photography* (New York, 1977), pp. 13–14; and in Pat Barker's *Double Vision* (New York, 2004), the investigation of photographs left by a war correspondent killed in action.

Conclusion

1 Jan Baetens and Hilde van Gelder, 'Petite poétique de la photographie mise en roman (1970–1990)', in Danièle Méaux, ed.,

Select Bibliography

Abrams, Meyer H., *The Mirror and the Lamp: Romantic Theory and the Critical Tradition* (Oxford, 1953)

Agee, James, and Walker Evans, *Let Us Now Praise Famous Men* [1941] (Boston, MA, 2001)

Armstrong, Carol, *Fiction in the Age of Photography: The Legacy of British Realism* (Cambridge, 1999)

—, 'Reflections on the Mirror: Painting, Photography, and the Self-Portraits of Edgar Degas', *Representations*, XXII (Spring 1988), pp. 108–41

Armstrong, Nancy, *Scenes in a Library: Reading the Photograph in the Book* (Cambridge, 1998)

Baetens, Jan, 'Conceptual Limitations of our Reflection on Photography', in *Photography Theory*, ed. James Elkins (New York, 2007), pp. 53–74.

Baetens, Jan, and Hilde van Gelder, 'Petite poétique de la photographie mise en roman (1970–1990)', in *Photographie et Romanesque*, *Études romanesques x*, ed. Danièle Méaux (Caen, 2006), pp. 257–72

Baier, Wolfgang, *Quellendarstellungen zur Geschichte der Fotografie* (Munich, 1977)

Baillargeon, Claude, *Dickensian London and the Photographic Imagination* (Rochester, 2003)

Bailly, Jean-Christophe, *L'Instant et son ombre* (Paris, 2008)

Bann, Stephen, and Emmanuel Hermange, eds, 'Photography and Literature', *Journal of European Studies*, XXX/117 (March 2000)

Barthes, Roland, *Barthes by Barthes*, trans. Richard Howard (New York, 1977)

—, *Camera Lucida, Reflections on Photography*, trans. Richard Howard (New York, 1981)

—, *Image–Music–Text* (New York, 1977)

Batchen, Geoffrey, *Burning with Desire: The Conception of Photography* (Cambridge, 1997)

Baudrillard, Jean, *Sur la photographie* (Paris, 1999)

Benjamin, Walter, 'A Short History of Photography' [1931], trans. Phil Patton, in *Classic Essays on Photography*, ed. Alan Trachtenberg (New Haven, CT, 1980), pp. 199–216

Berger, John, *About Looking* (New York, 1980)

Blackwood, Sarah, '"The Inner Brand": Emily Dickinson, Portraiture, and the Narrative of Liberal Interiority', *Emily Dickinson Journal*, XIV/2 (Fall 2005), pp. 48–59

Bogardus, Ralph, *Pictures and Texts: Henry James, A. L. Coburn, and New Ways of Seeing in Literary Culture* (Ann Arbor, MI, 1984)

Bolton, Richard, ed., *The Contest of Meaning: Critical Histories of Photography* (Cambridge, 1989)

Boorstin, Daniel J., *The Image: A Guide to Pseudo-Events* (New York, 1961)

Bossert, Helmut and Heinrich Guttmann, *Aus der Fruhzeit der Photographie 1840–70* (Frankfurt am Main, 1930)

Bouchart. François-Xavier, *Proust et la figure des pays* (Paris, 1982)

Bourdieu, Pierre, *The Rules of Art: Genesis and Structure of the Literary Field*, trans. Susan Emanuel (Stanford, CA, 1996)

Brassai, *Proust in the Power of Photography*, trans. Richard Howard (Chicago, IL, 2001)

Brunet, François, '"Picture Maker of the Old West": W. H. Jackson and the Birth of Photographic Archives in the US', *Prospects*, XIX (1994), pp. 161–87

—, 'Poe à la croisée des chemins: réalisme et scepticisme', *Revue Française d'Études Américaines*, LXXI (January 1997), pp. 44–50

—, *La Naissance de l'idée de photographie* (Paris, 2000)

—, '"Quelque chose de plus": la photographie comme limite du champ esthétique (Ruskin, Emerson, Proust)', in *Effets de cadre, De la limite en art*, ed. Brunet et al. (Saint-Denis, 2003), pp. 29–52

—, 'Revisiting the Enigmas of Timothy H. O'Sullivan, Notes on the William Ashburner Collection of King Survey Photographs at the Bancroft Library', *History of Photography*, XXXI/2 (Summer 2007), pp. 97–133

—, 'Inventing the Literary Prehistory of Photography: From François Arago to Helmut Gernsheim', forthcoming in *Literature and Photography: New Perspectives*, ed. Julian Luxford and Alexander Marr (St Andrews, 2009)

—, and Bronwyn Griffith, eds, *Images of the West: Survey Photography in the American West, 1860–80* (Chicago, IL, 2007)

Bryant, Marsha, ed., *Photo-Textualities: Reading Photographs and Literature* (Newark, NJ, 1996)

Bussard, Katherine A., *So the Story Goes: Photographs by Tina Barney, Philip-Lorca diCorcia, Nan Goldin, Sally Mann, and Larry Sultan* (Chicago, 2006)

Bustarret, Claire, 'Vulgariser la Civilisation: science et fiction "d'après photographie"', in *Usages de l'image au xixe siècle*, ed. Stéphane Michaud et al. (Paris, 1992), pp. 129–42

Cadava, Eduardo, *Words of Light: Theses on the Photography of History* [2nd edn] (Princeton, NJ, 1998)

Chapman, Alison, '"A Poet Never Sees a Ghost": Photography and Trance in Tennyson's Enoch Arden and Julia Margaret Cameron's Photography', *Victorian Poetry*, XLI/1 (Spring 2003), pp. 47–71

Chéroux, Clément, 'Les récréations photographiques, un répertoire de formes pour les avant-gardes', *Études photographiques*, V (November 1998), pp. 73–96

—, ed., *The Perfect Medium: Photography and the Occult* (New Haven, CT, 2005)

Chevrier, Jean-François, *Proust et la photographie* (Paris, 1982)

Chouard, Géraldine, 'Eudora Welty's Photography or the Retina of Time', *Études Faulknériennes*, V (June 2005), pp. 19–24

Coleman, A. D., 'The Directorial Mode: Notes toward a Definition' [1976], in *Light Readings: A Photography Critic's Writings, 1968–1978* (New York, 1979), pp. 246–57

Cosgrove, Peter, 'Snapshots of the Absolute: Mediamachia in *Let Us Now Praise Famous Men*', *American Literature*, LXVII/2 (1995), pp. 329–57

Crary, Jonathan, *Techniques of the Observer: On Vision and Modernity in the Nineteenth Century* (Cambridge and London, 1990)

Crimp, Douglas, 'The Museum's Old / The Library's New Subject' [1984], in *The Contest of Meaning: Critical Histories of Photography*, ed. Richard Bolton (Cambridge, 1989), pp. 3–13

Daguerre, Louis-J.-M., *Historique et description des procédés du Daguerréotype et du Diorama* (Paris, 1839)

Davidson, Cathy N., 'Photographs of the Dead: Sherman, Daguerre, Hawthorne', *South Atlantic Quarterly*, LXXXIX/4 (Fall 1990), pp. 667–701

De la Sizeranne, Robert, 'La photographie est-elle un art?', *Revue des Deux Mondes*, 4th period, CXLIV (November–December 1897), pp. 564–95

De Mondenard, Anne, *La Mission Héliographique: Cinq photographes parcourent la France en 1851* (Paris, 2002)

Debray, Régis, *Vie et mort de l'image* (Paris, 1995)

—, *L'œil naïf* (Paris, 1994)

Eastlake, Elizabeth, 'Photography' [1857], in *Photography: Essays and Images*, ed. Beaumont Newhall (New York, 1980), pp. 81–96. French translation of this essay, with notes by François Brunet, *Études Photographiques*, XIV (January 2004), pp. 105–7.

Edwards, Kathleen A., *Acting Out: Invented Melodrama in Contemporary Photography* (Seattle, OR, 2005)

Edwards, Paul, 'Roman 1900 et photographie (les editions Nillson/Per Lamm et Offenstadt Frères)', *Romantisme*, CV/3 (1999), pp. 133–44

—, 'The Photograph in Georges Rodenbach's "Bruges-la-Morte" (1892)', *Journal of European Studies*, XXX/117 (2000), pp. 71–89

—, *Soleil noir: Photographie et littérature des origines au surréalisme* (Rennes, 2008).

Elkins, James, ed., *Photography Theory* (New York, 2007)

Études Photographiques, XX (June 2007): 'La trame des images, Histoire de l'illustration photographique'

Figuier, Louis, 'La photographie', *Exposition et histoire des principales découvertes scientifiques modernes* (Paris, 1851), pp. 1–72

Folsom, Ed, *Walt Whitman's Native Representations* (Cambridge, 1997)

Foucault, Michel, *The Order of Things: An Archaeology of the Human Sciences*, trans. Alan Sheridan (New York, 1970)

—, 'La peinture photogénique' [1975], in *Dits et écrits*, vol. II (Paris, 1994), pp. 708–15

Frank, Waldo, et al., *America and Alfred Stieglitz: A Collective Portrait* (New York, 1934)

Freund, Gisèle, *La photographie en France au dix-neuvième siècle: essai de sociologie et d'esthétique* (Paris, 1936)

—, *Photography and Society*, trans. Richard Dunn (Boston, MA, 1980)

Gernsheim, Helmut, *The Origins of Photography* (London, 1982)

—, *Incunabula of British Photographic Literature: A Bibliography of British Photographic Literature 1839–75 and British Books Illustrated with Original Photographs* (Berkeley, CA, 1984)

Gidley, Mick, *Edward S. Curtis and the North American Indian, Incorporated* (Cambridge, 1998)

Goldberg, Vicki, ed., *Photography in Print: Writings from 1816 to the Present* (New York, 1981)

Goldschmidt, Lucien, and Weston J. Naef, *The Truthful Lens: A Survey of the Photographically Illustrated Book, 1844–1914* (New York, 1980)

Graham, Wendy, 'Pictures for texts', *Henry James Review*, XXIV/1 (2003), pp. 1–26

Green, Jonathan, *Camera Work A Critical Anthology* (Washington, DC, 1973)

Green-Lewis, Jennifer, *Framing the Victorians: Photography and the Culture of Realism* (Ithaca, NY, 1997)

Greenough, Sarah E., and Juan Hamilton, *Alfred Stieglitz: Photographs and Writings*, (Washington, DC, 1983)

Grojnowski, Daniel, and Philippe Ortel, eds, *Romantisme*, CV/3 (1999): 'L'imaginaire de la photographie'

Grossmann, Julie, 'Hardy's "Tess" and "The Photograph": Images to Die For – Thomas Hardy', *Criticism*, XXXV (Fall 1993), pp. 609–31

Groth, Helen, 'Consigned to Sepia: Remembering Victorian Poetry', *Victorian Poetry*, XLI/4 (Winter 2003), p. 613

—, *Victorian Photography and Literary Nostalgia* (New York, 2003)

Gunthert, André, 'L'inventeur inconnu, Louis Figuier et la constitution de l'histoire de la photographie française', in *Études Photographiques*, XVI (May 2005), pp. 7–16

Hamon, Philippe, *Imageries, littérature et image au XIXe siècle* (Paris, 2001)

Hamon, Philippe, 'Pierrot photographe', in *Romantisme*, CV/3 (1999), pp. 35–44

Hansen, Miriam, 'Mass Culture as Hieroglyphic Writing: Adorno, Derrida, Kracauer', *New German Critique*, LVI (Spring–Summer, 1992), pp. 43–73

Harvey, John, *Photography and Spirit* (London, 2007)

Hayes, Kevin J., 'Poe, the Daguerreotype, and the Autobiographical Act', *Biography*, XXV/3 (Summer 2002), pp. 477–92

Heilbrun Françoise, et al., *En collaboration avec le soleil: Victor Hugo, photographies de l'exil* (Paris, 1998)

Holmes, Oliver W., 'The Stereoscope and the Stereograph' [1859], in *Photography: Essays and Images*, ed. Beaumont Newhall (New York, 1980), pp. 53–62

Holmes, Oliver W., 'Sun Painting and Sun Sculpture', *The Atlantic Monthly*, VIII (July 1861), pp. 13–29

—, 'Doings of the Sunbeam' [1863], in *Photography: Essays and Images*, ed. Beaumont Newhall (New York, 1980), pp. 63–78

Humm, Maggie, *Modernist Women and Visual Cultures: Virginia Woolf, Vanessa Bell, Photography, and Cinema* (New Brunswick, NJ, 2003)

Ivins, William, *Prints and Visual Communication* (London, 1953)

Jackson, William Henry, *Time Exposure* [1940] (Albuquerque, NM, 1986)

Jameson, Frederick, *The Political Unconscious: Narrative as a Socially Symbolic Act* (Ithaca, NY, 1981)

Jammes, André, and Eugenia Parry Janis, *The Art of French Calotype, with a Critical Dictionary of Photographers, 1845–1870* (Princeton, NJ, 1983)

Jammes, Isabelle, *Blanquart-Evrard et les origines de l'édition photographique française* (Geneva and Paris, 1981)

Jennings, Michael, 'Agriculture, Industry, and the Birth of the Photo-Essay in the Late Weimar Republic', *October*, XCIII (Summer 2000), pp. 23–56

Joyeux, Odette, *Nièpce, Le Troisième Œil* (Paris, 1989)

Jussim, Estelle, *Visual Communication and the Graphic Arts: Photographic Technologies in the Nineteenth Century* (New York, 1974)

Kelsey, Robin, *Archive Style, Photographs and Illustrations for US Surveys, 1850–1890* (Berkeley, CA, 2007)

Leclerc, Yvan, 'Portraits de Flaubert et de Maupassant en photophobes', *Romantisme*, CV/3 (1999), pp. 97–106

Lambrechts, Eric, and Luc Salu, *Photography and Literature: An International Bibliography of Monographs* (London, 1992)

Lindsay, Vachel, *De la caverne à la pyramide (Ecrits sur le cinéma 1914–1925)*, ed. Marc Chénetier (Paris, 2001)

Lugon, Olivier, *Le Style documentaire d'August Sander à Walker Evans* (Paris, 2002)

Luxford, Julian, and Alexander Marr, *Literature and Photography: New Perspectives* (forthcoming St Andrews, 2009)

Lyotard, Jean-François, *The Postmodern Condition: A Report on Knowledge*, trans. Geoff Bennington and Brian Massumi (Manchester, 1984)

McCauley, Anne, 'François Arago and the Politics of the French Invention of Photography', in *Multiple Views: Logan Grant Essays on Photography 1983–89*, ed. Daniel P. Younger (Albuquerque, NM, 1991), pp. 43–70

McLuhan, Marshall, *Understanding Media: The Extensions of Man*, critical edn by W. Terrence Gordon (Corte Madera, CA, 2003)

Mary Warner Marien, *Photography and its Critics: A Cultural History, 1839–1900* (Cambridge and New York, 1997)

Méaux, Danièle, ed., *Photographie et Romanesque*, *Études romanesques*, X (Caen, 2006)

Michaud, Eric, "Daguerre, un Prométhée chrétien", *Études Photographiques*, II (May 1997), pp. 44–59

Meehan, Sean Ross, 'Emerson's Photographic Thinking', *Arizona Quarterly: A Journal of American Literature, Culture, and Theory*, LXII/2 (Summer 2006), pp. 27–58

Mitchell, W.J.T., *Iconology: Image, Text, Ideology* (Chicago, IL, 1986)

—, *Picture Theory* (Chicago, IL, 1994)

Montier, Jean-Pierre, 'D'un palimpseste photographique dans *Les Travailleurs de la mer* de Victor Hugo', in *Photographie et Romanesque*, *Études romanesques*, X, ed. Danièle Méaux (Caen, 2006), pp. 49–68

—, et al., *Littérature et photographie* (Rennes, 2008)

Naef, Weston J., and James N. Wood *Era of Exploration: the Rise of Landscape Photography in the American West* (New York, 1976)

Nancy, Jean-Luc, and Philippe Lacoue-Labarthe, *The Literary Absolute: The Theory of Literature in German Romanticism* [1980], trans. Philip Barnard and Cheryl Lester (Albany, NY, 1988)

Newhall, Beaumont, *Latent Image: The Discovery of Photography* (New York, 1966)

—, ed., *Photography: Essays and Images* (New York, 1980)

Nickel, Douglas, *Dreaming in Pictures: The Photography of Lewis Carroll* (New Haven, CT, 2002)

Olsen, Victoria C., *From Life: The Story of Julia Margaret Cameron and Victorian Photography* (New York, 2003)

Ortel, Philippe, *La Littérature à l'ère de la photographie, Enquête sur une revolution invisible* (Nîmes, 2002)

Orvell, Miles, *The Real Thing: Imitation and Authenticity in American Culture, 1880–1940* (Chapel Hill, NC, 1989)

—, 'Virtual Culture and the Logic of American Technology', *Revue Française d'Études Américaines*, LXXVI (March 1998), pp. 12–27

—, *American Photography* (Oxford, 2003)

Parr, Martin, and Gerry Badger, *The Photobook: a History*, vols I and II (New York, 2004/2006)

Phillips, Christopher, *Photography in the Modern Era: European Documents and Critical Writings, 1913–1940* (New York, 1989), pp. 15–46

—, 'The Judgment Seat of Photography', in *The Contest of Meaning: Critical Histories of Photography*, ed. Richard Bolton (Cambridge, 1989), pp. 15–46

Poivert, Michel, 'Politique de l'éclair. André Breton et la photographie', *Études photographiques*, VII (May 2000), pp. 52–72

Potonniée, Georges, *Cent ans de photographie* (Paris, 1940)

Rabb, Jane, ed., *Literature and Photography, Interactions 1840–1990* (Albuquerque, NM, 1995)

—, ed., *The Short Story and Photography 1880's–1990's: A Critical Anthology* (Albuquerque, NM, 1998)

Recht, Roland, *La Lettre de Humboldt* (Paris, 1989)

Rodenbach, Georges, *Bruges-la-Morte* [1892], ed. Jean-Pierre Bertrand and Daniel Grojnowski (Paris, 1998)

Roubert, Paul-Louis, *L'image sans qualités, Les beaux-arts et la critique à l'épreuve de la photographie 1839–1859* (Paris, 2006)

Sandweiss, Martha, *Print the Legend: Photography and the American West* (New Haven, CT, 2002)

Sartre, Jean-Paul, *L'Imaginaire* (Paris, 1940)

Schaaf, Larry, *Out of the Shadows: Herschel, Talbot, and the Invention of Photography* (New Haven, CT, and London, 1992)

Schaaf, Larry, *Records of the Dawn of Photography: Talbot's Notebooks P & Q* (Cambridge and Melbourne, 1996)

—, *The Photographic Art of William Henry Fox Talbot* (Princeton, NJ, 2000)

—, *Introductory Volume to the Anniversary Facsimile of H. Fox Talbot's "The Pencil of Nature"* (New York, 1989)

Scharf, Aaron, *Art and Photography* (Baltimore, MD, 1969)

Seifrid, Thomas, 'Gazing on Life's Page: Perspectival Vision in Tolstoy', *PMLA*, CXIII/3 (May, 1998), pp. 436–48

Sekula, Alan, 'On the Invention of Photographic Meaning' [1975], in *Photography in Print: Writings from 1816 to the Present*, ed. Vicki Goldberg (New York, 1981), pp. 452–73

Shloss, Carol, *In Visible Light: Photography and the American Writer* (New York, 1987)

Signorini, Roberto, *Alle origini del fotografico, Lettura di 'The Pencil of Nature' (1844–46) di William Henry Fox Talbot* (Bologna, 2007)

Smith, Graham, *'Light that Dances in the Mind': Photographs and Memory in the Writings of E. M. Forster and his Contemporaries* (Oxford, 2007)

Sobieszek, Robert A., ed., *The Prehistory of Photography: Original Anthology* (New York, 1979)

Sontag, Susan, *On Photography* (New York, 1977)

Stange, Maren, *Symbols of Ideal Life: Social Documentary Photography in America, 1890–1950* (New York, 1992)

Stiegler, Bernd, 'La surface du monde: note sur Théophile Gautier', *Romantisme*, CV (1999/3), pp. 91–5

—, '*"Mouches volantes"* et *"papillons noirs"*: Hallucination et imagination littéraire, note sur Hippolyte Taine et Gustave Flaubert', in *Photographie et Romanesque, Études romanesques*, X, ed. Danièle Méaux (Caen, 2006), pp. 9–48

Stott, William, *Documentary Expression in Thirties America* (New York, 1973)

Szarkowski, John, *The Photographer's Eye* (New York, 1966)

—, *Mirrors and Windows* (New York, 1978)

Taft, Robert, *Photography and the American Scene: A Social History 1839–1889* [1938] (New York, 1964)

Taylor, Roger, and Edward Wakeling, *Lewis Carroll, Photographer* (Princeton, NJ, 2002)

Thélot, Jérôme, *Les inventions littéraires de la photographie* (Paris, 2004)

Thomas, Richard F., *Literary Admirers of Alfred Stieglitz* (Carbondale, IL, 1983)

Tick, Stanley, 'Positives and Negatives: Henry James vs. Photography', *Nineteenth Century Studies*, VII (1993), pp. 69–101

Trachtenberg, Alan, ed., *Classic Essays on Photography* (New Haven, CT, 1980)

—, *Reading American Photographs: Images as History, Mathew Brady to Walker Evans* (New York, 1989)

—, 'Seeing and Believing: Hawthorne's Reflections on the Daguerreotype in "The House of the Seven Gables"', *American Literary History*, IX/3 (Autumn 1997), pp. 460–81

Virilio, Paul, *The Aesthetics of Disappearance* [1980], trans. Philip Beitchman (New York, 1991)

Von Amelunxen, Hubertus, 'Quand le photographie se fit lectrice: le livre illustré par la photographie au XIXème siècle', *Romantisme*, XV/47 (1985), pp. 85–96

—, *Die Aufgehobene Zeit. Die Erfindung der Photographie durch William Henry Fox Talbot* (Berlin, 1989)

Waldrep, Shelton, *The Aesthetics of Self-invention: Oscar Wilde to David Bowie* (Minneapolis, MN, 2004)

Weaver, Mike, *The Photographic Art: Pictorial Traditions in Britain and America* (New York, 1986)

Wells, Liz, ed., *The Photography Reader* (New York, 2002)

Weston, Edward, *The Daybooks of Edward Weston*, ed. Nancy Newhall [1966] (New York, 1990)

Wey, Francis, 'Comment le soleil est devenu peintre, Histoire du daguerréotype et de la photographie', *Musée des Familles*, XX (1853), pp. 257–65, 289–300

Whitfield, Stephen J., 'The Image: The Lost World of Daniel Boorstin', *Reviews in American History*, XIX/2 (June 1991), pp. 302–12

Wilsher, Ann, 'Photography in Literature: The First Seventy Years', *History of Photography*, II/3 (July 1978), pp. 223–54

—, 'The Tauchnitz "Marble Faun"', *History of Photography*, IV/1 (January 1980), pp. 61–6

Zannier, Italo, *Il Sogno della Fotografia* (Collana, 2006)

Acknowledgements

I wish to thank most warmly Mark Haworth-Booth for inviting me
to write this book, and Vivian Constantinopoulos and Harry Gilonis
for their resourcefulness and cooperation. I am deeply grateful to my
research centre, the Laboratoire de Recherches sur les Cultures
Anglophones, at Université Paris Diderot – Paris 7, and its director
Frédéric Ogée, for according me a very generous grant to cover the
costs of acquiring illustrations. To my dear colleague Catherine Bernard
I owe a special debt for her expert, insightful reading. Among the many
people who helped me through the thickets of gathering illustration
materials I want to thank particularly Larry Schaaf, Carol Johnson
(Library of Congress), and Shannon Perich (Smithsonian Institution).
My gratitude also goes to photographers Elizabeth Lennard, Jeff Wall
and Raymond Depardon for their liberality. Finally, I am pleased to
acknowledge the crucial help of Carole Troufléau (Société Française de
Photographie), Barbara Galasso (George Eastman House), Raphaëlle
Cartier (Réunion des Musées Nationaux), Violet Hamilton (Wilson
Centre for Photography), Bernhard Krauth (Jules Verne Club),
Christian Passeri (Musée Niépce), Clément Chéroux (Musée National
d'Art Moderne), Françoise Dauphragne (Ecole Normale Supérieure),
Marc Walter and Lucien de Samosate. As always, however, my biggest
debt is to Lilli Parrott and her unfailing support.

Photo Acknowledgements

The author and publishers wish to express their thanks to the following sources of illustrative material and/or permission to reproduce it:

Photo © Agence-France Presse: 78; courtesy of the Bancroft Library, University of California, Berkeley, CA: 28; courtesy of the Estate of Roland Barthes and Editions du Seuil, Paris: 38; courtesy of the Bayerisches Nationalmuseum, Munich: 6; Beinecke Library, New Haven, CT: 80; Bibliothèque Nationale de France, Paris: 7; photos courtesy Bibliothèque Nationale de France, Paris: 8, 9, 10, 11; photo © Yvan Bourhis – DAPMD – Conseil général de Seine-et-Marne: 72; photo © Guy Carrard, Musée National d'Art Moderne, Paris: 33; Columbia University Rare Book Library, New York: 39; courtesy of Raymond Depardon: 61; photo courtesy of the Library of the Ecole Normale Supérieure, Paris: 83; courtesy Farrar, Straus & Giroux, New York: 51; courtesy of George Eastman House (International Museum of Photography and Film), Rochester, NY: 5, 42, 45, 49, 74, 76, 82; photos © Estate of Gisèle Freund: 48, 77; © Christine Guibert: 86, 89; courtesy of the Jules Verne Club: 46; © Elizabeth Lennard: 64; Library of Congress, Washington, DC (Prints and Photographs Division): 15 (Office of War Information), 17, 29, 34, 25 (photos 1, 3 and 4 by Oscar Rejlander, photo 2 by Adolph D. Kindermann), 40, 43, 52, 58, 67, 70, 71 (Prokudin-Gorskii Collection); photos courtesy Library of Congress, Washington, DC: 27, 30, 31, 37, 69, 85; © Man Ray Trust – ADAGP, Paris 2008: 79; Médiathèque de l'Architecture et du Patrimoine, Paris: 2, 4; photo courtesy of the Médiathèque de la Cinémathèque Française, Paris: 50; photo reproduced courtesy Thomas Meyer: 80; courtesy of the Ministère de la Culture – Médiathèque du Patrimoine, Dist. RMN / © André Kertesz: 2; © Duane Michals: 63; photo courtesy Musée National d'Art Moderne, Paris: 33, 47 (© Man Ray Trust / ADAGP, photo © CNAC / MNAM, Dist. RMN / rights reserved), 48 (photo © CNAC / MNAM, Dist. by RMN / © Georges Meguerditchian), 77 (photo © CNAC / MNAM, Dist. by RMN / © Georges Meguerditchian); courtesy of the Musée Nicéphore Niépce, Châlon-sur-Saône: 24; courtesy National Museum of American History (Smithsonian Institution), Washington, DC: 13, 14, 16, 18, 21, 22, 23, 26, 66; photos courtesy National Museum of American History (Smithsonian Institution), Washington, DC: 19, 20; courtesy Pace / MacGill Gallery, New York: 63; © Gordon Parks, courtesy of the Gordon Parks Foundation: 60; photos © RMN: 59 (photo © CNAC / MNAM, Dist. RMN / Georges Meguerditchian); photo © RMN (Musée d'Orsay, Paris)/rights reserved: 68; © RMN / © Hervé Lewandowski: 75, 79; Musée d'Orsay, Paris (photos © RMN / Hervé Lewandowski): 41, 54; © Musée d'Orsay (Dist. RMN / Jean-Jacques Sauciat): 73; private collections: 44, 55, 56, 88; reproduced courtesy of the author (Leslie Scalapino) and O Books: 35, 36; courtesy of the artist (Cindy Sherman) and Metro Pictures: 87; © Collection of the Société Française de Photographie, Paris – all rights reserved: 1, 3, 12, 53, 62, 90; courtesy of Jean and Dimitri Swetchine: 71; courtesy of Jeff Wall: 65; courtesy of Marc Walter, Paris: 57; courtesy of the Wilson Photographic Centre, London: 81.

Index

Numbers in *italic* refer to pages on which illustrations are reproduced.